*"Santa Claus is anyone who loves
another and seeks to make them happy;
who gives himself by thought or word
or deed in every gift that he bestows."*
—Edwin Osgood Grover

"The real Santa Claus is at the mall."
—Lemony Snicket

WE ARE SANTA

PORTRAITS AND PROFILES

Ron Cooper

————

PRINCETON ARCHITECTURAL PRESS · NEW YORK

You might ask, What about the one real Santa?
He's asked us not to tell you which one he is, but if you
look closely, you just might spot him in these pages.

Dear Friends of Santa,

Children (You) may wonder about the many different
Santas pictured in these pages. The explanation
is simple. While we elves are busy in our workshops,
Santa needs other helpers, helpers he chooses
carefully to be patient, kind, and jolly. You'll
notice certain similarities among them, the same
way you might notice similarities between family
members. All year, these Santas keep busy, supervising
toy making up here at the North Pole, training
the reindeer, and traveling far and wide to see how
the children of the world are behaving. Remember,
Santa's list has to be checked twice—it's a big
job that takes a whole year. That's why we see Santa's
helpers in so many different places, dressed in so
many different ways.

Sincerely,
Your friends from the North Pole

Published by
Princeton Architectural Press
202 Warren Street, Hudson, New York 12534
www.papress.com

© 2021 Ron Cooper
All rights reserved. Printed and bound in China
24 23 22 21 4 3 2 1 First edition

ISBN 978-1-61689-965-3

Editor: Lynn Grady
Designer: Paul Wagner

Library of Congress Cataloging-in-Publication Data
available upon request.

Erica Stull's skills as a writer are evident in these pages. She has taken tons of information and distilled it into highly readable and entertaining prose. If you've enjoyed reading the stories and profiles in this book, it's all due to Erica.

I met my first professional Santa Claus three years ago in New Mexico, where I was photographing cowboys, gunslingers, snake handlers, and Civil War–era reenactors. One subject made a convincing 1860s Union soldier, complete with authentic costume and rifle musket. After we had completed the shoot, he asked if he could show me a very different character that he portrayed. I agreed, and he returned fifteen minutes later as Santa Claus.

Shortly after that, I saw a news story about the Charles W. Howard Santa School, the oldest Santa training program in the nation. This idea—that there is an actual school for Santas— was a new one to me, but I was immediately intrigued by the serious-ness with which the school's students pursued the art and craft of embodying Santa Claus. It wasn't long before I learned that Santa Claus is the most photographed character *in the world*. That's when I thought to myself, who better, then, to be the focus of a new photography project? Santa, of course.

I've always enjoyed meeting and photographing people who follow their passions, especially when those ambitions take them far outside the realm of their daily lives. In addition to historical reenactors, I've photographed clowns, drag queens, and, of course, Santas. On the surface, they are very different groups of people, but these "transformers" are united in their commitment to their callings and in their eagerness to creatively reinvent themselves physically as they embody their characters of choice.

With the assistance of two leading Santa booking agents,
I arranged photo shoots with dozens of top professional Santas in
cities across the country. I asked them to arrive at the studio
in street clothes—no bells, no red suit—so that I could take their
portraits, to be presented in black and white.

That's when the real fun began. In what was often an elaborate
and lengthy physical transformation, each Santa changed into his
favorite suit for another set of photographs, this time in full color.
Through these photo sessions, I learned a lot about Santa's wardrobe
and accessories, as well as special padding and all manner of props.
Many brought two or more suits for distinct looks, and as I traveled
from city to city, I found myself both surprised and impressed
by the diversity and range of the character we know simply as Santa.

More importantly, I learned about the dedication,
professionalism, commitment, and character of these people. They
are deeply devoted to their mission—to the children they meet,
to the integrity of their persona, to the spirit of the season, and to
the history and traditions of Santa Claus. Each one is an inspiration.

Ron Cooper, 2020

Who Is Santa? Santa Is *Everywhere*!

The origin of Santa Claus dates back to the third century and a man named Nicholas. Nicholas was Bishop of Myra in what is now known as Turkey. He developed a reputation for generosity, giving away his inherited wealth to those in need. Saint Nicholas, as he came to be known, was the patron saint of children and sailors, and, in his honor, a tradition of gift giving was born. That tradition spread across Europe, and children began to look forward to the night before Nicholas's name day, December 6, as a kind of holiday. Hundreds of years later, Dutch sailors brought Sinter Klaas—a shortened version of Sint Nikolaas—to colonial America, where he was represented as a tall, slender bishop.

In the North American colonies, the Dutch figure of Sinter Klaas merged with the English concept of Father Christmas, a big man in fur-lined green or red robes, and Santa Claus transformed into the man we know today. In parts of the US, he became known as Kris Kringle, a name derived from the Austrian and German Christkindl tradition, in which well-behaved children received presents during the Christmas season.

Santa's appearance was established for future generations in 1823, when the *Troy Sentinel* newspaper in New York published Clement Clarke Moore's poem "A Visit from St. Nicholas," also known as "'Twas the Night Before Christmas." Moore described a roly-poly, "jolly old elf" dressed in fur and sporting a white beard.

In 1863, political cartoonist Thomas Nast, a supporter of Abraham Lincoln and Ulysses S. Grant, used Moore's poem to create "Santa Claus in Camp," a cartoon in *Harper's Weekly* that showed Santa distributing gifts in a Union Army camp. Santa is depicted with a full white beard and dressed in a patriotic,

stars-and-stripes, ensemble. Two years later, Nast brought Santa back to the *Harper's* Christmas issue, and made him an annual holiday tradition. His 1881 full-page illustration of "Merry Old Santa Claus," now in his signature red suit with fur trim, is often considered Santa's first official portrait.

Santa made his department store debut in 1890, when James Edgar, a heavyset dry-goods store owner in Brockton, Massachusetts, had a tailor make him a Nast-style Santa suit. He roamed the store as Santa, talking to children and spreading Christmas cheer. Word of a real, live Santa got out, and Edgar eventually attracted visitors from as far away as New York and Rhode Island. By the turn of the century, children were waiting in long lines to talk to Santa at department stores across the United States and Canada.

Macy's Herald Square store in New York held its first Thanksgiving Day Parade in 1924, with Santa presiding from a throne on the balcony above the store's 34th Street entrance. Since then, his arrival at the end of the parade has been a traditional kickoff of the holiday season.

The most familiar modern image of Santa was created by Haddon Sundblom, who painted a jovial Santa for a Coca-Cola ad in 1931. Once again, the artist's inspiration was Moore's "A Visit from St. Nicholas," with a friend serving as the painter's model. Sundblom's Santa appeared in Coke ads in popular magazines every year through 1964, cementing him as an icon in the American imagination.

WE ARE SANTA

Ward A. **BOND** b. 1970

LOCATION
Anderson, Indiana &
Long Island, New York

OCCUPATION
Carpenter, woodworker,
carver, cabinetmaker

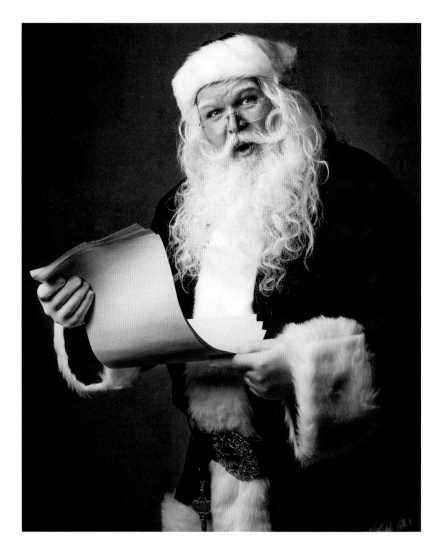

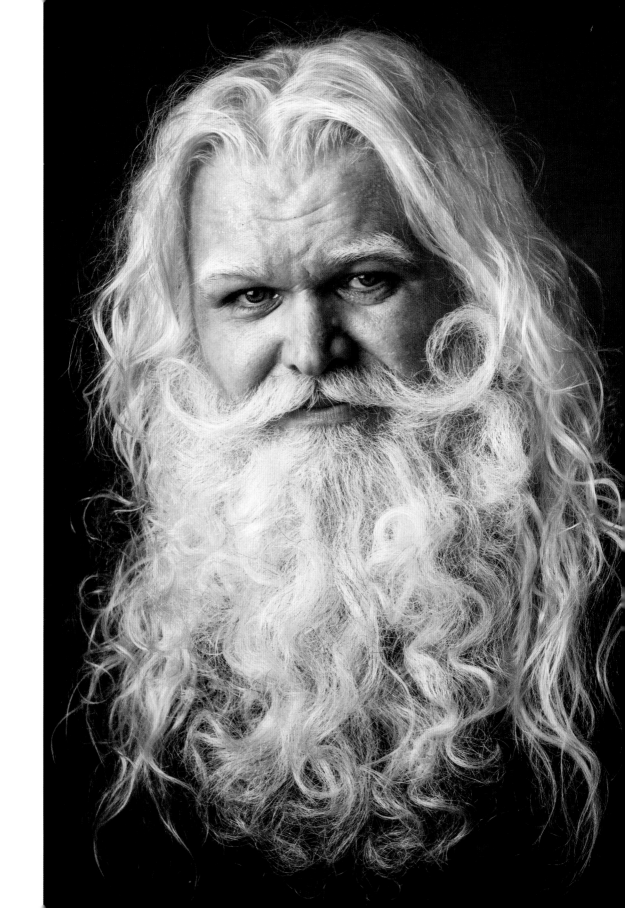

"The first time a three-year-old came running up with his arms out saying, 'I love you, Santa,' my heart was so full of love and joy, I thought, 'I have to do this for these kids.'" Ward Bond found his calling in 2015, after he had started growing a beard. A pastor friend had suggested he'd be a great Santa and loaned him a suit to try it out. Bond had played Santa casually in the past, but his spontaneous encounter with that excited and loving child sealed the deal.

In his first year, **SANTA WARD** joined the Hoosier Santas, a group of Indiana-based professional Santas who get together every month to socialize, practice Santa craft, and organize volunteer and charitable activities in their communities. Bond also studied Santa history and learned how to answer hard questions. He found video and audio materials to help him perfect his ho-ho-ho. "I wanted to do it right, so I wouldn't ruin the magic of Christmas for anyone," he says.

After his first year, Bond was recruited by a commercial photography studio in Long Island, New York. The studio is decorated as Santa's workshop, and Santa interacts with visiting children during half-hour photo sessions. Bond now lives in Long Island from mid-September through Christmas Eve, spending his days as Santa Ward. Prepared with advance information provided by parents, Bond improvises a memorable experience for each child. He sees each visit as "an opportunity to bring joy to children's lives, even if just for a moment."

Before becoming Santa, Bond was a carpenter, and he continues to enjoy woodworking—he carves distinctive Santa staffs—as well as metalworking and electronic design. He stays busy with a variety of creative projects. He's writing a novel as well as a series of children's books about Santa. He also plays music with his wife, and the music corner in his Indiana home includes a ukulele and percussion instruments for his grandchildren.

Bond sees Santa as the "embodiment of hope, love, and joy," and he takes his responsibilities seriously. "The sparks of wonder we create make that Christmas magic last a lifetime. There's a lot of gravity to that. It's an honor to be Santa for so many families, to create that memory. Because life changes things. Thirty years from now, when they look back at that photo, they'll remember."

Santa Ward believes his experience as Santa has helped him show his softer side. "I know what it feels like to need someone to show you that they care," he says. "That's one of the driving forces to be what I can be for people. Santa has open arms and an open heart for everyone who needs it."

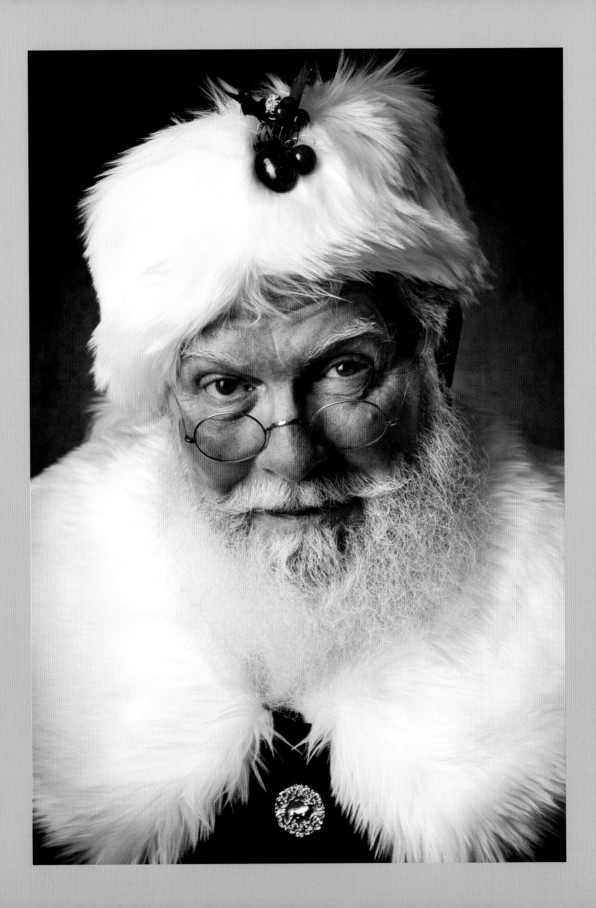

KJ **BRAITHWAITE** b. 1955

LOCATION
Colorado Springs,
Colorado

OCCUPATION
Customer service and sales executive
(retired), singer, musician, songwriter

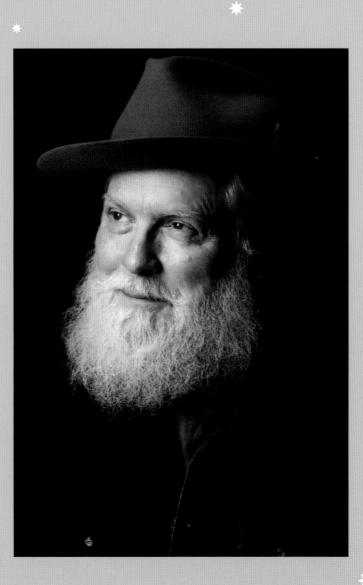

Music has always been an essential part of Christmas for **SANTA KJ BRAITHWAITE**. His mother was a gifted pianist, and he remembers lining up with his two older siblings to sing carols and other Christmas songs for the family every Christmas Eve— a tradition he carries on with his own children. Following his lifelong passion for music, he's been singing and playing guitar for forty-five years with a wide variety of bands, all in addition to his day job as a corporate executive. As Santa, he has woven music into his work at every opportunity. "I keep a ukulele in my bag," he says. "You never know when you might be able to use it. Music is very much part of the Santa spirit."

No surprise, then, that music figures into Santa KJ's most memorable experience. "A little girl, about five years old, marched up with her father, and he said, 'Santa, Sally has a gift for you.' I had her step up on the stool facing me, and she proceeded to sing a Christmas carol to me in the most beautiful little voice, strong and clear. We were eye to eye, and I held her hands as she sang. I took every moment into my heart and gave my heart back to her."

Although he says he has always been Santa in spirit, Braithwaite is in his sixth year as a professional. The door to playing Santa opened when a musician friend, a professional Santa, told Braithwaite about the attributes the work required. "A light bulb went on. I thought I had all those qualities." As he approached retirement, he decided the time was right to don the red suit. He attended Santa school before taking on his first assignment and continues to study his craft. "It's an ongoing process to be the best Santa you can be. You do it because you have a calling," he says.

Santa KJ and his Mrs. Claus, Carol, have worked as a team, performing whenever possible. They got their marriage license at a courthouse in 2015, the day before attending Denver's Professional Santa Claus School together, and then had an all-Claus ceremony when they graduated. A fellow student who was also a clergyman officiated, and about forty Santas in full regalia attended the event.

Being Santa and Mrs. Claus has had a strong and lasting impact on their marriage, Santa KJ says. "It strengthens us—it's a very big piece of us. And it's not far off of who we are anyway. We're respectful of each other, we have the same vision, our humor together is wonderful, so we can bring that to the children; it's one of the strong suits of our relationship. It's sort of cemented us together."

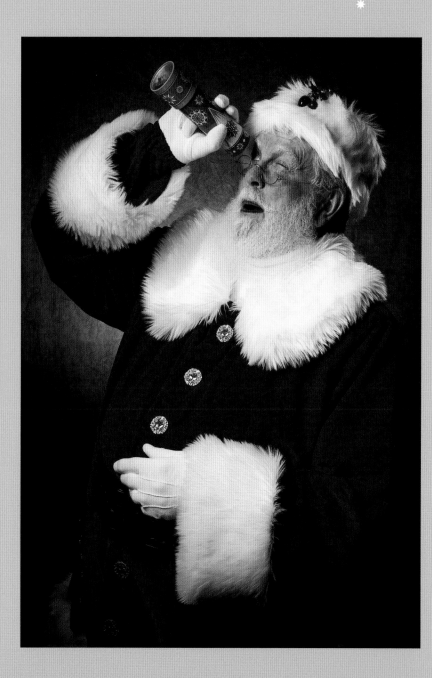

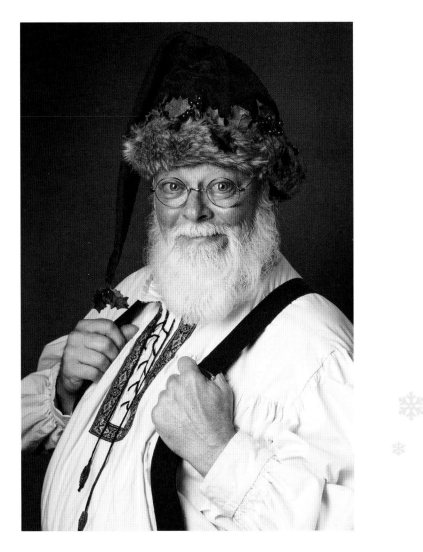

Willie **BROSSEAU** b. 1962

LOCATION
Fredericksburg, Virginia

OCCUPATION
Maintenance supervisor

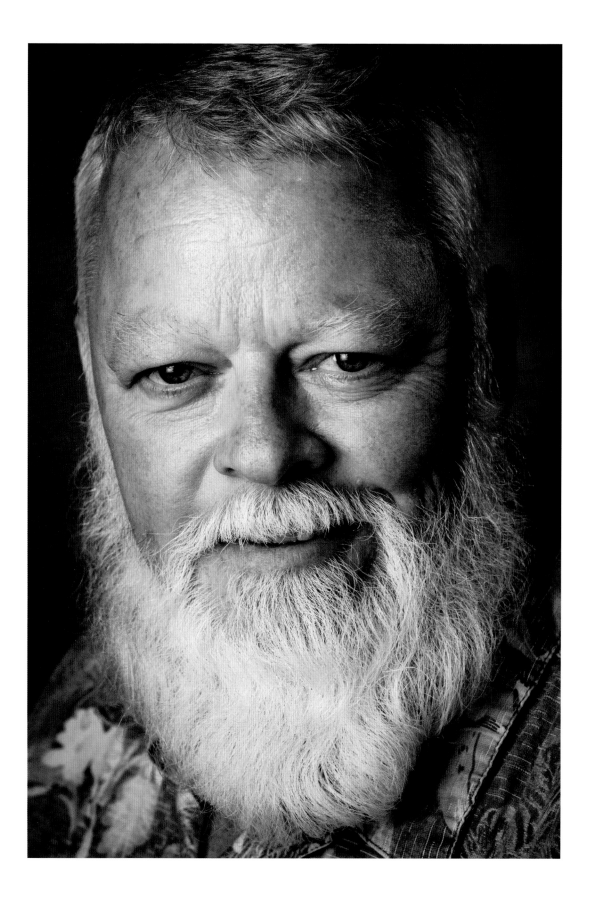

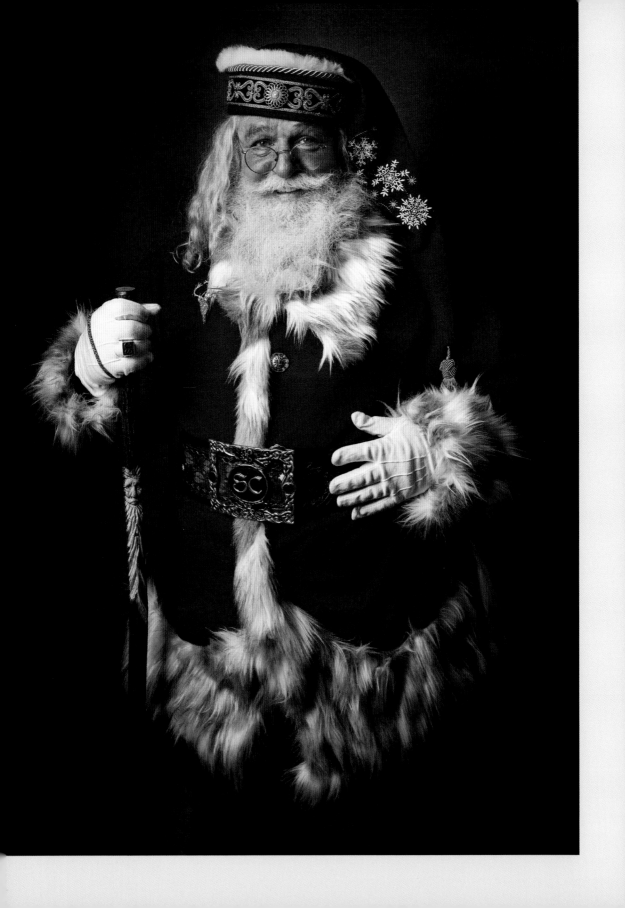

Billy **BROWN** b. 1960

LOCATION
Windsor, Virginia

OCCUPATION
Small business owner

"The times I get to spend being Santa are the most fulfilling moments of my life."

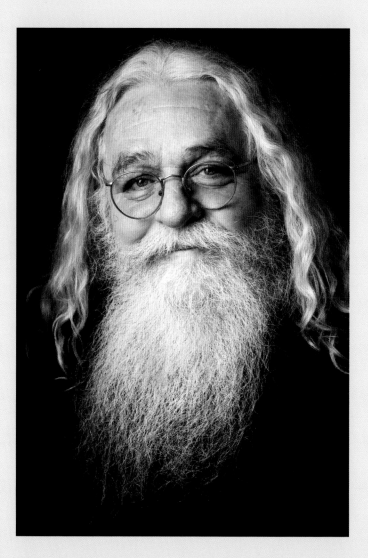

"We recently gave my two-year-old granddaughter a cookie that was shaped and iced to look like Santa's face. Grandma asked her, 'Who does that cookie look like?' She didn't miss a beat. 'Grandpa!' Then she ate it."

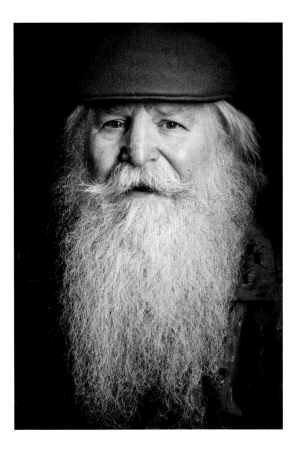

George **CAMPBELL** b. 1950

LOCATION
Bedford, Texas

OCCUPATION
Executive creative director, marketing, advertising

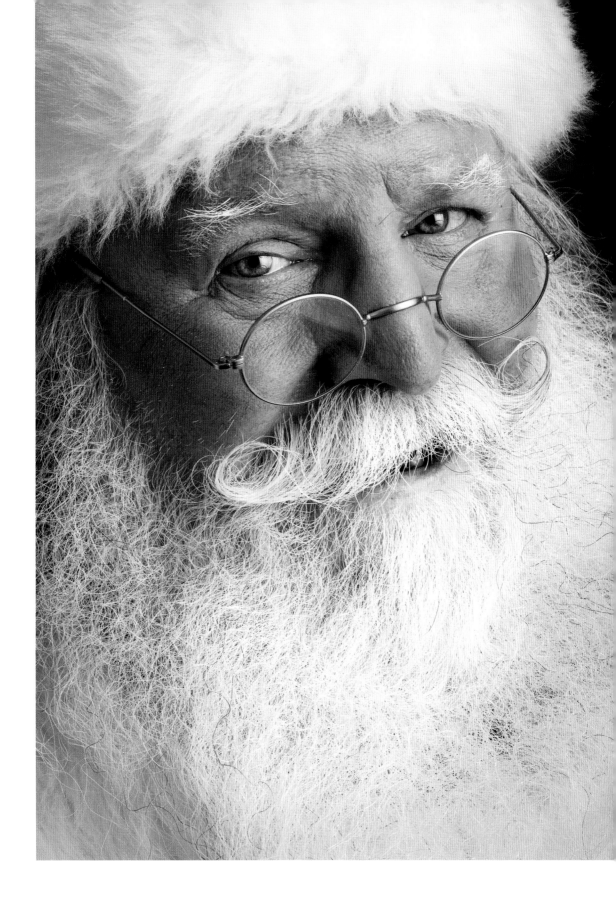

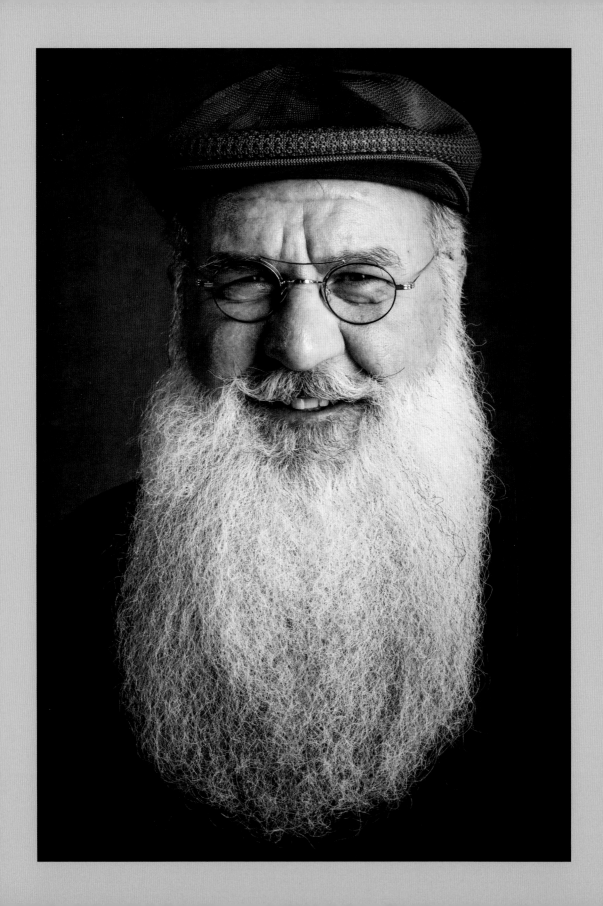

Nicholas **CARDELLO** b. 1963

LOCATION
Tampa, Florida

OCCUPATION
Photojournalist, freelance photographer

"What's my best quality as Santa? I've always been incurably optimistic and love to be around people. Having a white beard and years of testing out cookies turned me into Santa naturally without much effort!"

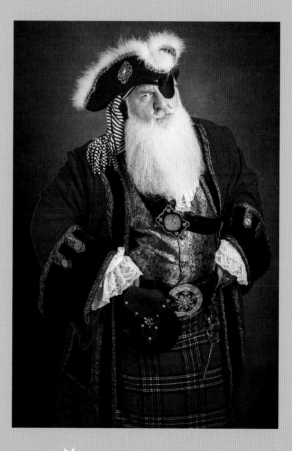

Thomas J. **CARROLL** b. 1960

LOCATION
Richmond, Virginia

OCCUPATION
Computer systems consultant

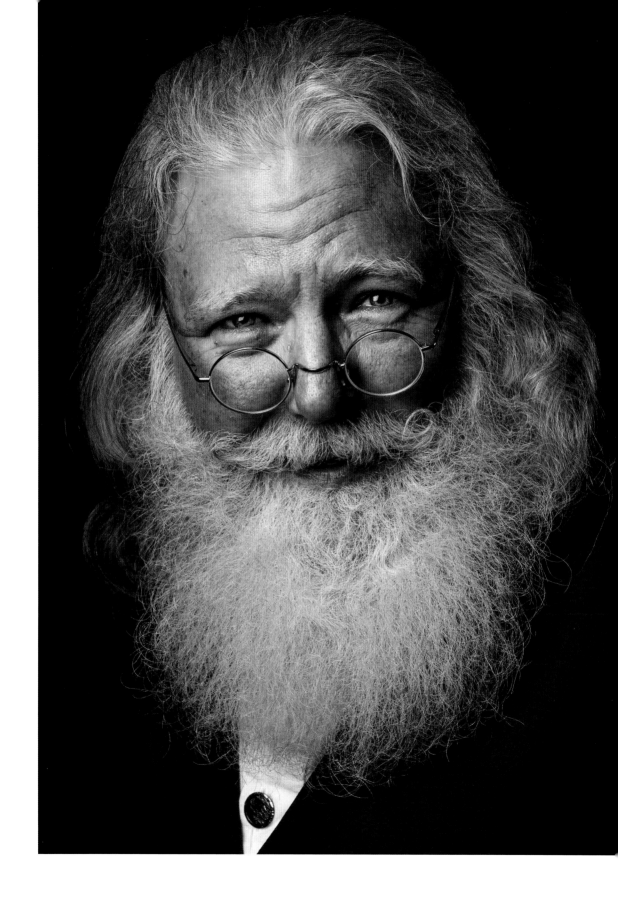

Thomas Carroll works in information technology for a large bank and agreed to serve as Santa for the company's big holiday party some twenty years ago. The bank bought him a beautiful Santa suit, but then the company announced layoffs and canceled the party. He tried to return the suit to the colleague who had bought it, but she had left the bank—and so had her boss. Carroll eventually connected with an executive who couldn't find any record of the purchase and told Carroll to keep the suit, so he decided to put it to good use. That year, he wore it to deliver packages of useful items to hundreds of Sudanese refugees who had recently settled in Richmond under the auspices of local church and volunteer agencies. It seemed that Carroll was destined to become **SANTA TOM**.

Well before his Santa days, Carroll had dedicated much of his life to helping young people in need. In addition to raising two biological children and adopting a teenager, Carroll and his wife, Shonnie, have been foster parents for twenty-five years. When they found out that their first two foster children had special emotional needs, the couple, determined to become better parents, learned about providing therapeutic foster care. The eighteen children they have fostered over the years include three Sudanese Lost Boys and a Vietnamese refugee.

After his first Santa experience, Carroll embraced his new mission with gusto. He learned his craft from other Virginia Santas, and he now reads extensively, attends classes, and applies his experience as a therapeutic foster parent to his efforts as Santa. His wife is a certified dementia practitioner, and the couple has taught Santa school classes on working with Alzheimer's and dementia patients. "They all remember Santa," he says.

Santa Tom and Shonnie, who regularly dresses as Mrs. Claus, appear at a local theme park and visit private parties during the holiday season. Santa Tom loves talking with children and has a special soft spot for teenagers. "They need to have some fun," he says. "If you can get them to laugh with you, you've won a big thing." Being Santa, he says, "can be staggeringly beautiful, it can be painful, it can fill you with more joy than you ever thought was available."

Carroll's most memorable experience involves the mother of a young visitor. As the boy was telling Santa his wishes, Carroll noticed the mother staring at him and growing increasingly emotional.

She insisted on introducing Santa to her husband, who shook his hand and left, as confused as Santa Tom. "You don't remember me; I met you at a party two years ago with my son," the mother finally told him. "After talking to my son, you asked me if I wanted anything for Christmas, and I said I wanted my husband to come back safely from Iraq. You told me that Santa was a toy maker, and you couldn't guarantee my wish, but that you'd pray for him if I gave you his name. You wrote it down in a little red book from your pocket. Mike was in Iraq for eighteen months. He came home in good shape. Best Santa ever!" Carroll found the red book with the soldier's name. "You never know the impact you'll have on someone."

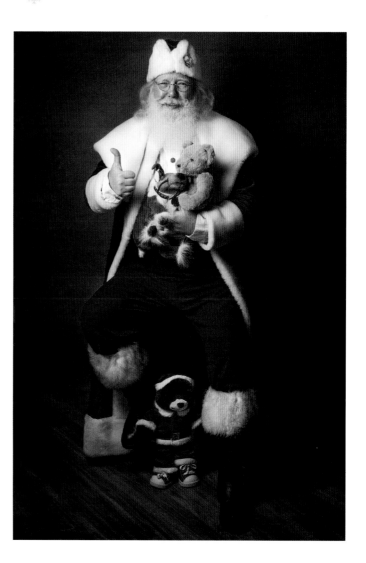

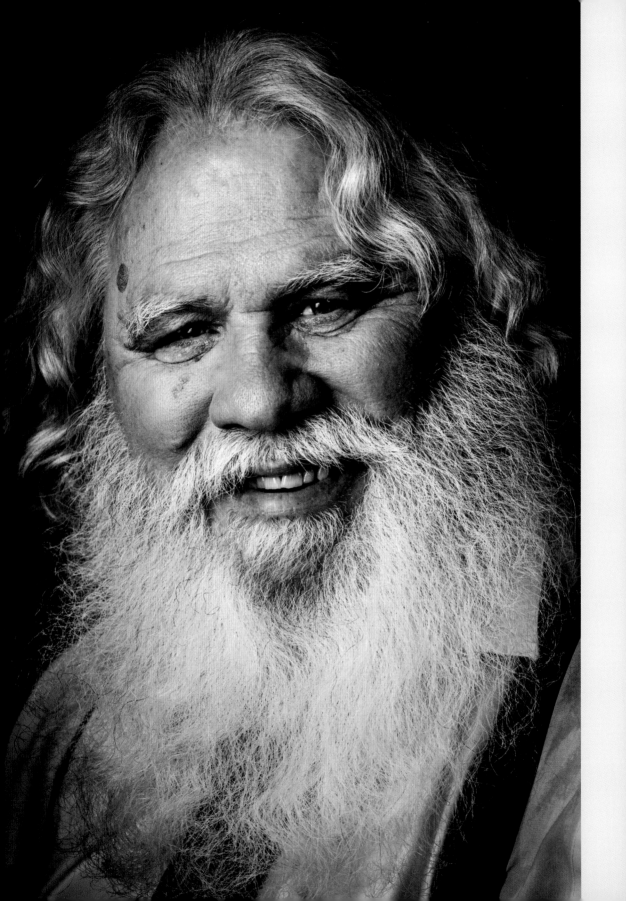

Michael **CHAPMAN** b. 1948

"What gives me the most satisfaction from my work as Santa? Being able to see the same families every year. Visiting with a thirty-four-year-old mother and her four-year-old and recalling a visit with that mother thirty years ago when she was the same age as her daughter is today."

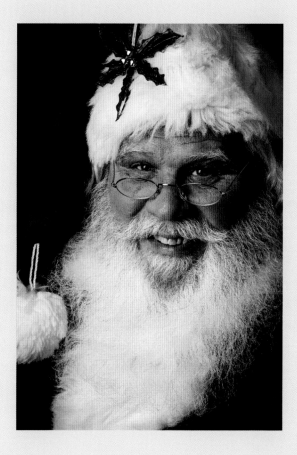

Learning the Art of Santa

———

There's infinitely more to being Santa than just a suit, a beard, and a hearty "ho-ho-ho." Elite practitioners spend considerable time polishing their skills in schools and professional organizations that flourish across the United States, even around the globe.

The first of these institutions was the Charles W. Howard Santa Claus School, which opened its doors in 1937 in upstate New York. The school's namesake, Charles W. Howard, held one of the nation's premier holiday posts, serving as the Macy's Thanksgiving Day Parade Santa from 1948 to 1965. Decades later, his school now flourishes in Midland, Michigan, where a new generation of Santas are taught Howard's guiding philosophy: "He errs who thinks Santa enters through the chimney. Santa enters through the heart."

Other yuletide educators have followed in Howard's footsteps, creating schools that specifically cater to the Santa experience. Schools include Santa Rick Rosenthal's Northern Lights Academy in Atlanta, Georgia; Susen Mesco's Professional Santa Claus School in Denver, Colorado; and Santa Timothy Connaghan's International University of Santa Claus, which holds classes in different host cities each year.

In training classes, hopeful and eager Santa students learn the fine points of fashion, beard care, and personal grooming. Among other things, students are advised to avoid garlic and to keep nose and ear hair carefully trimmed. (Alcohol and tobacco are, of course, taboo.) Students learn how to avoid back injury while lifting children and the best way to pose for photos. They practice smiling and ho-ho-ho-ing, learning to vary their volume for the situation and the child. Then there's the business side

of being Santa: invoicing, scheduling, working with an agent … Santa must do it all.

Yet practical considerations are just one part of the training curriculum. Equally important is understanding and immersing oneself in Santa's backstory so that all students have a fully developed narrative of his life. As part of the job, Santa must be able to think quickly and clearly and always be ready to expound on a whole variety of topics—from the North Pole, reindeer, and elves to the whereabouts of Mrs. Claus. Since Santa must always be prepared for *anything*, cultivating strong improvisational skills is essential!

Most importantly, an elite Santa learns to form an immediate bond with each child or adult he meets. He learns the best questions to ask and also develops skills for relating to children and adults with special needs. Many Santas learn American Sign Language, and, in some cases, foreign languages so that they can better communicate with as many visitors as possible. Santas must have strategies for responding to visitors' most difficult questions and confidences—such as requests for miracles that Santa's magic may not be able to produce and less-than-festive revelations about children's home lives.

For the best Santas, the work never ends. They study the new toy releases and pick up new tricks of the trade. They return to classes and practice their craft locally with other members of their brotherhood. They are conscientious about doing whatever is necessary to honor the great responsibility of being Santa.

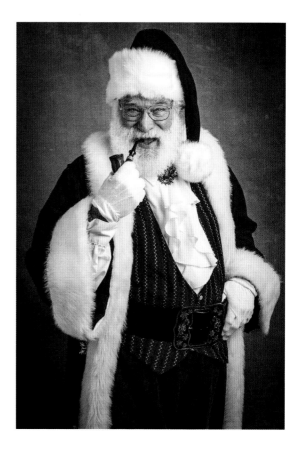

"Every year, Mrs. Claus and I go to Ronald McDonald House to visit with the children and take photos. Many come from out of town, even as far away as Russia. On one visit, we met Sofia, who wore a Superwoman costume day and night. She was being treated for brain cancer. That year, 2017, we got to celebrate her remission and return trip home. It was joyous."

SANTA CHARLIE SINCE 1994

Charlie **CRADY** b. 1949

LOCATION
Houston, Texas

OCCUPATION
Oil field equipment sales

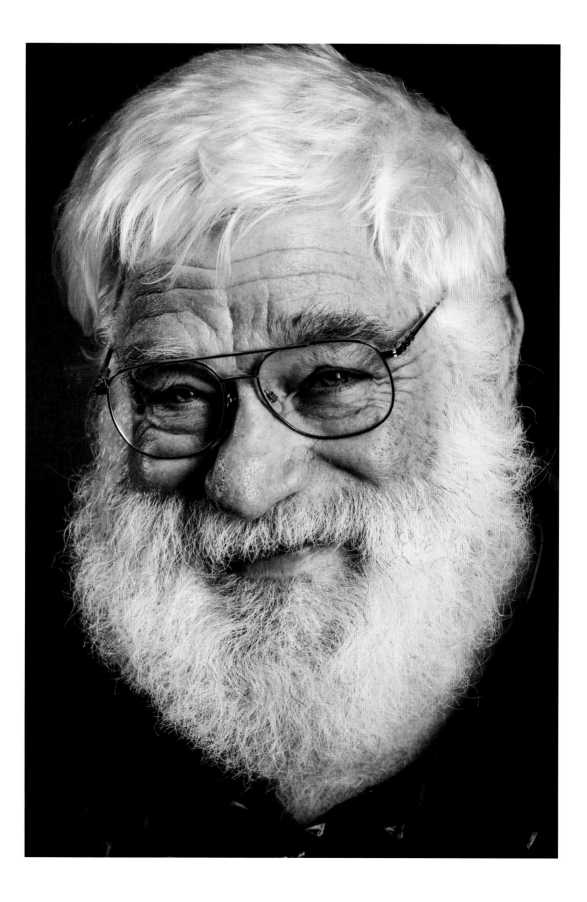

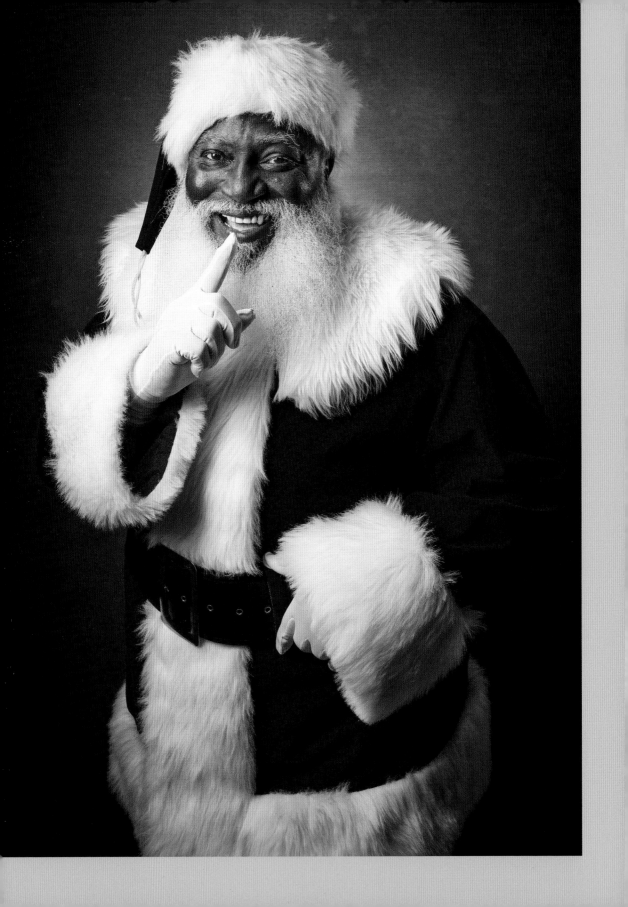

Michael **DARBY** b. 1955

LOCATION
Atlanta, Georgia

OCCUPATION
Entrepreneur

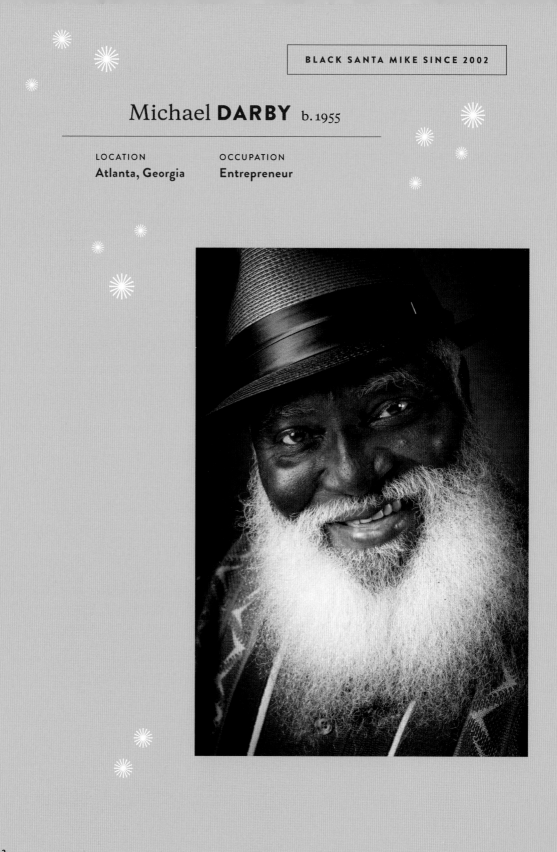

Ronald **DOMALEWSKI** b. 1954

LOCATION
Virginia Beach, Virginia

OCCUPATION
US Military (retired),
charter bus driver

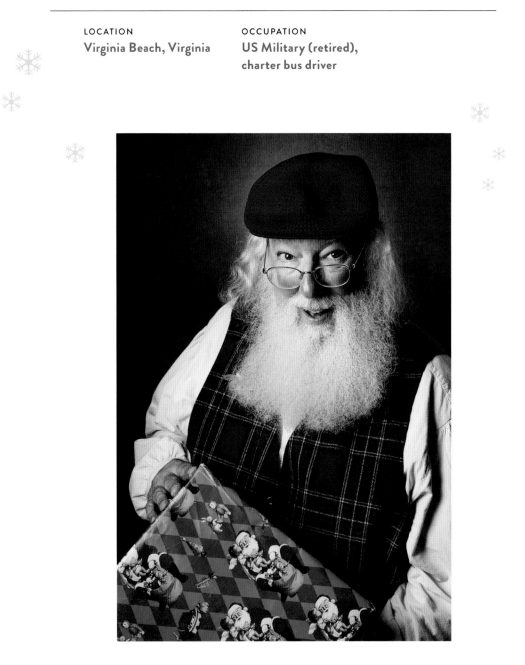

44

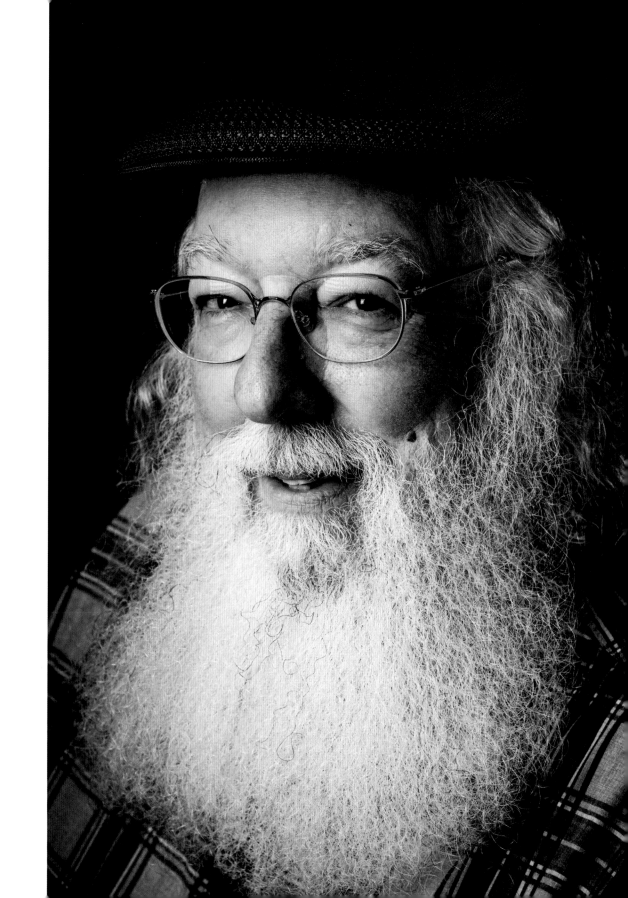

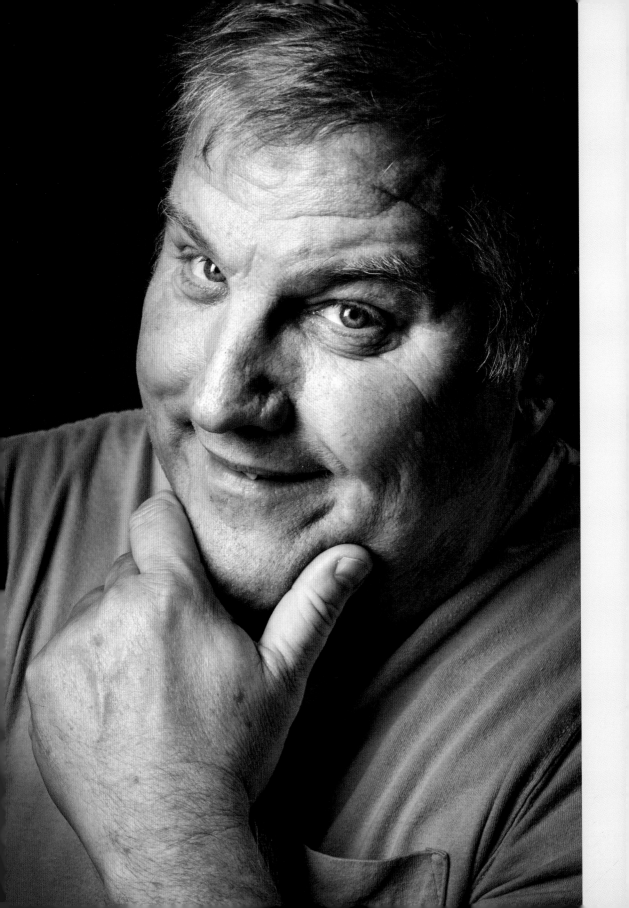

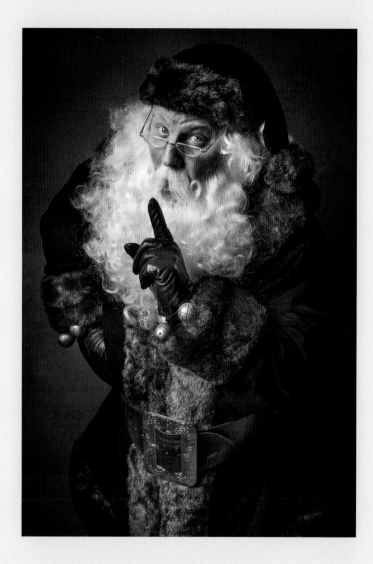

Doug **EBERHART** b. 1963

LOCATION
Charlotte, North Carolina

OCCUPATION
Medical sales representative

Doug Eberhart spends every December on the run, performing as **SANTA DOUG** as much as he can. In his most recent season, he appeared as Santa eighty-five times between Thanksgiving and Christmas Eve at public events and private parties for clients, including the NFL's Carolina Panthers. Christmas Eve is dedicated to home visits, where he looks forward to his best opportunity to interact with children. "There might be three to five kids, or if a number of families get together, as many as sixty. It's total chaos," he says, chuckling. "I might sing a song with them, or read *The Night Before Christmas.*"

Eberhart's Santa experience started in Massillon, Ohio, when he was fourteen. He was a football player—a big kid—and his father encouraged him to try being Santa as a way to earn money. "My mom made my first three suits using a pajama pattern," he says. "I put an ad in the local paper, and people would call me up for house calls." His parents drove him to appearances every year until he was old enough to drive himself. He continued his Santa work through his college years at Princeton University and kept it going into adulthood. After thirty-five years as Santa, he attended Charles W. Howard Santa Claus School in Michigan to refine his craft. He loved the camaraderie of the Santa community he found at the school and went on to attend other training programs.

When he's not being Santa Doug, Eberhart works in medical sales, a position he has held for thirty years. In 2018, he started the Pro Santa Shop, intending to build a small business for his retirement years down the road. He now serves Santas internationally with unique suits and props. "There were things I wanted as Santa that I couldn't find on the market, so I thought I'd just design them myself," he says. Eberhart is fascinated with Santa's changing appearance through history, and is inspired to create suits based on vintage postcards from the 1890s through the 1920s. A self-taught Santa fashion expert, he has gone to considerable lengths to find the best-performing velvets and furs, and hired seamstresses to bring his ideas to wearable life. He teaches fashion at a few Santa schools and encourages students to branch out and try looks beyond the standard red-and-white suit. Aspiring to be the "Liberace of Santas," he says, "I want to take the average Santa who doesn't know a thing about color or fur and make him look his best. He should walk into a room and have people say, 'Wow.'"

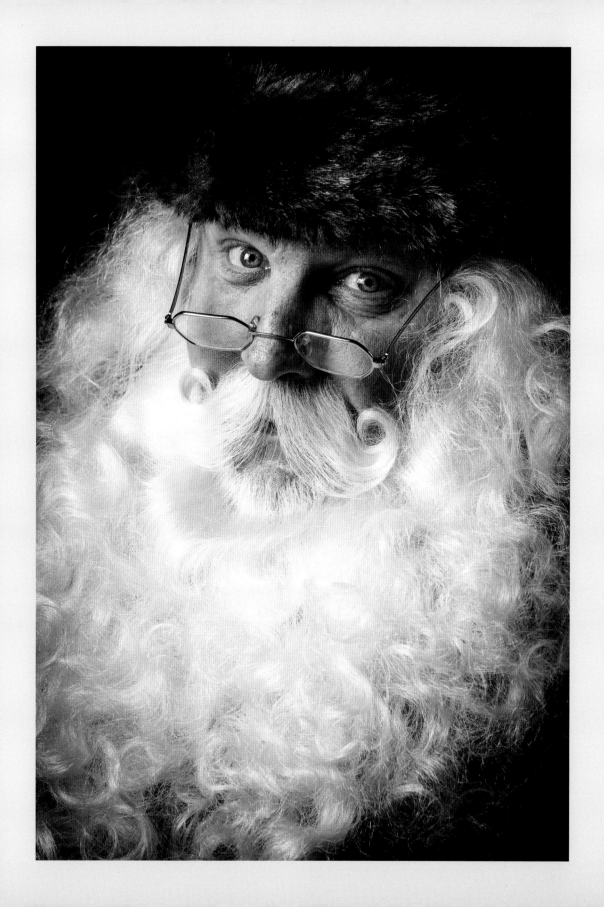

Perry T. **EIDSON** b. 1956

LOCATION
Grayson, Georgia

OCCUPATION
Fiber network engineer,
small business owner

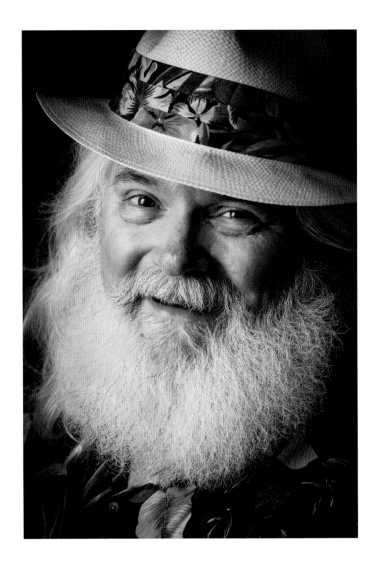

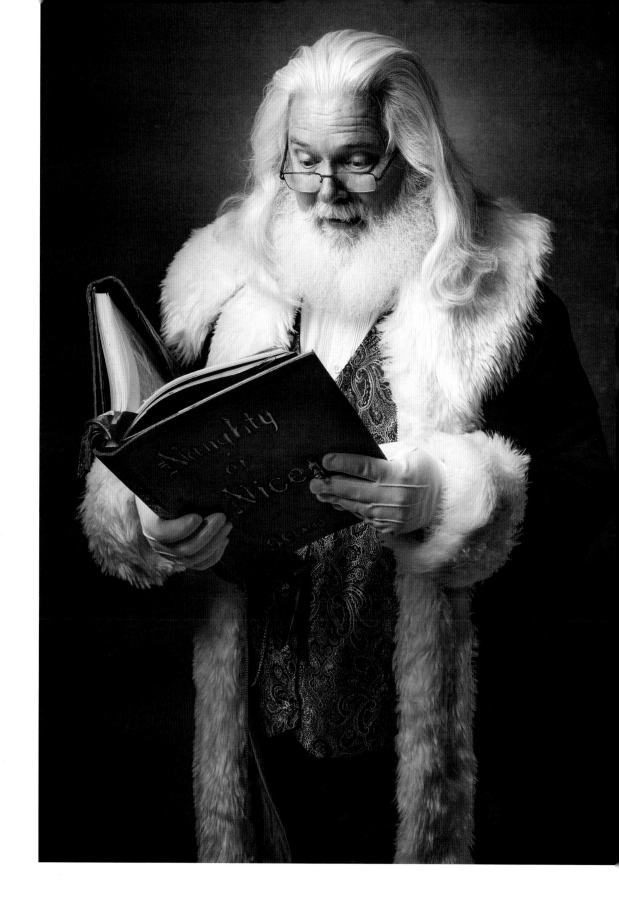

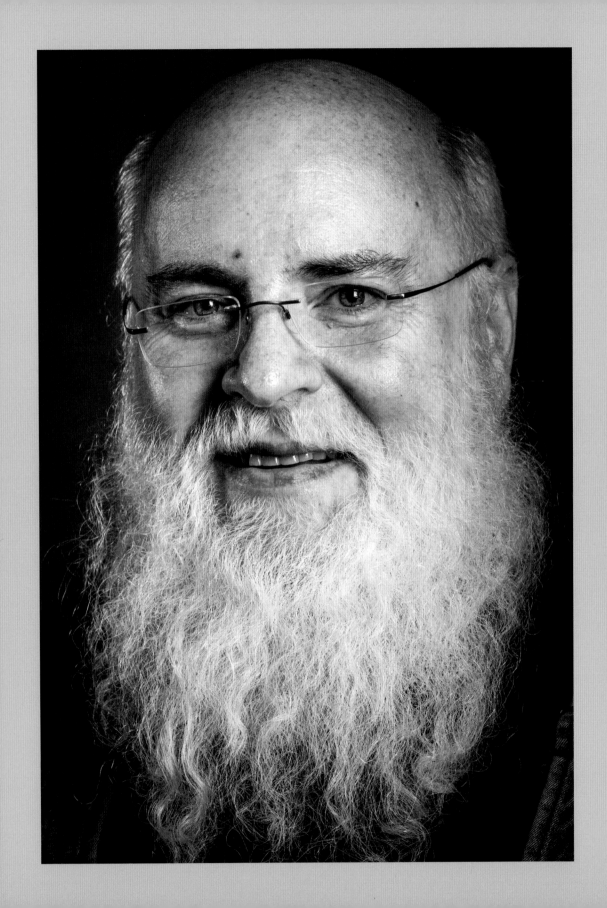

Felix Gilbert **ESTRIDGE** b. 1964

LOCATION
Wylie, Texas

OCCUPATION
**Business operations analyst (retired),
information technology**

*Santa Felix Estridge
has been Santa Claus at
the flagship Neiman
Marcus store in downtown
Dallas for the last twelve
years and has visited
with more than fifty
thousand children in his
Santa career.*

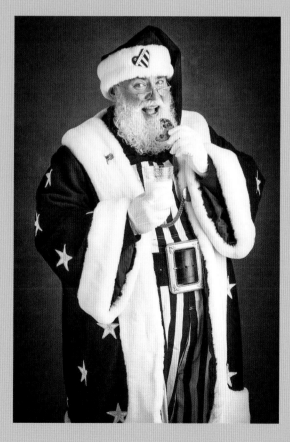

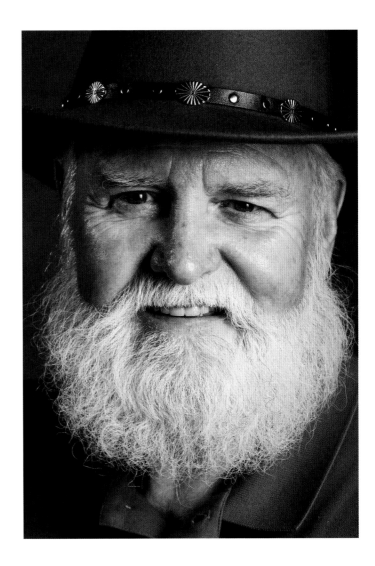

Ronald W. **FRAZIER** b. 1948

LOCATION
Anderson, Texas

OCCUPATION
Railroad industry sales,
auditing, maintenance

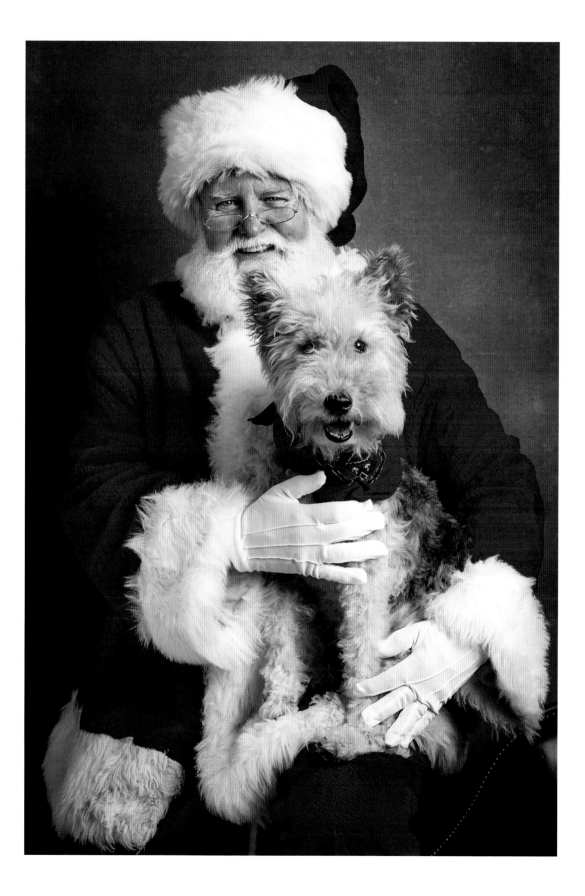

"God gave me the chance to touch lives, make people smile, and show the rewards of living with a gentle spirit."

John **FULLER** b. 1959

LOCATION
Winston, Georgia

OCCUPATION
Security engineer,
airline industry (retired)

Looking the Part

———

D edicated Santas often make significant financial investments in their wardrobe and costume. Each Santa transformation begins with the suit; indeed, most professionals own multiple suits to get them through the holiday season. Styles can vary widely, which is why many Santas have their own distinctive look, even though they are all still Santa.

The most popular look, which originated with the immortal 1931 Coca-Cola ad, features red trousers and a three-quarter-length red coat with brass buttons down the front and white fur trim on the bottom, collar, and sleeves. The look is accessorized with knee-high, fur-trimmed boots; a wide, black belt with a brass buckle; and a red hat trimmed with white fur and a pom-pom. Although the ad artist, Haddon Sundblom, based his painting on Thomas Nast's Civil War–era illustration, the outfit is now known as the "Coca-Cola suit."

Adele's of Hollywood, the most venerable purveyor of Santa suits, sells ready-made

Coca-Cola Santa suits in sizes ranging from large to 5XL. Prices start at $599, yet many Santas invest in custom-made suits, which are considerably pricier. And then there's the maintenance: dry cleaning alone is a significant item in Santa's budget.

Looks can vary widely, and many Santas become fashion connoisseurs. They may favor Father Christmas styles with longer coats, fur down the front, and gold trim. A colorful velvet or brocade vest allows Santa to take off his coat in warmer settings. In addition to the classic red-and-white, some Santa stores even offer vintage-style suits in dark green, gold, and white, with different varieties of white, brown, and black fur.

It doesn't stop there: a number of Santa suppliers focus just on accessories: gloves, belts, boots, and suspenders, as well as fancy belt buckles and brooches to be worn on the hat. For the discerning Santa, there are as many style options as there are ornaments on a Christmas tree.

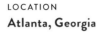

Bruce B. **GLASGOW** b. 1955

LOCATION
Atlanta, Georgia

OCCUPATION
Nuclear engineer, PhD

"My moustache and beard are difficult to control. I've tried everything…I give my moustache a big curl, and the only thing I've found that works is Elmer's Glue (washable)."

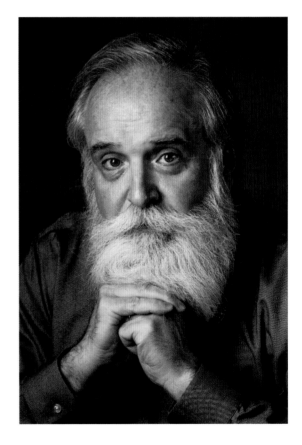

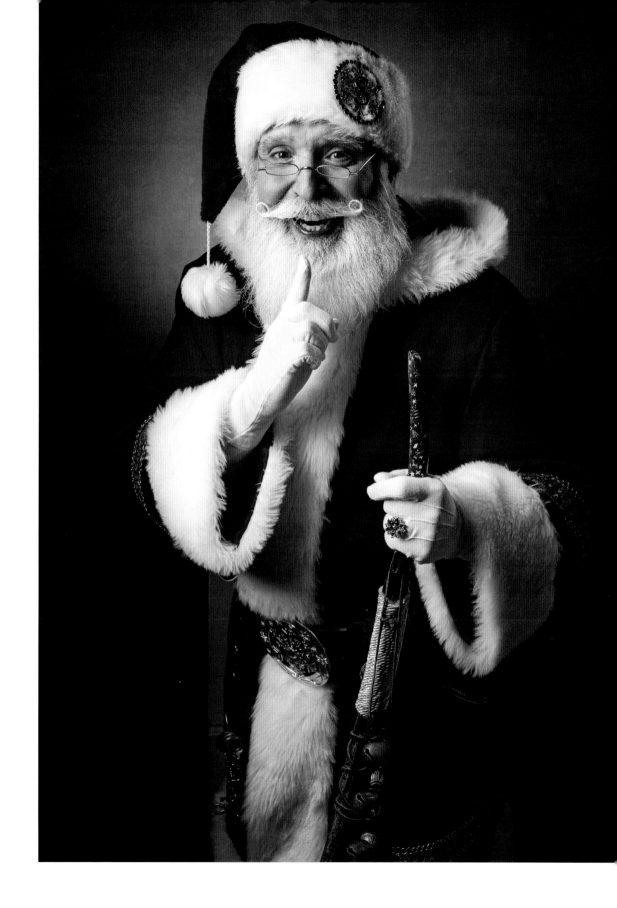

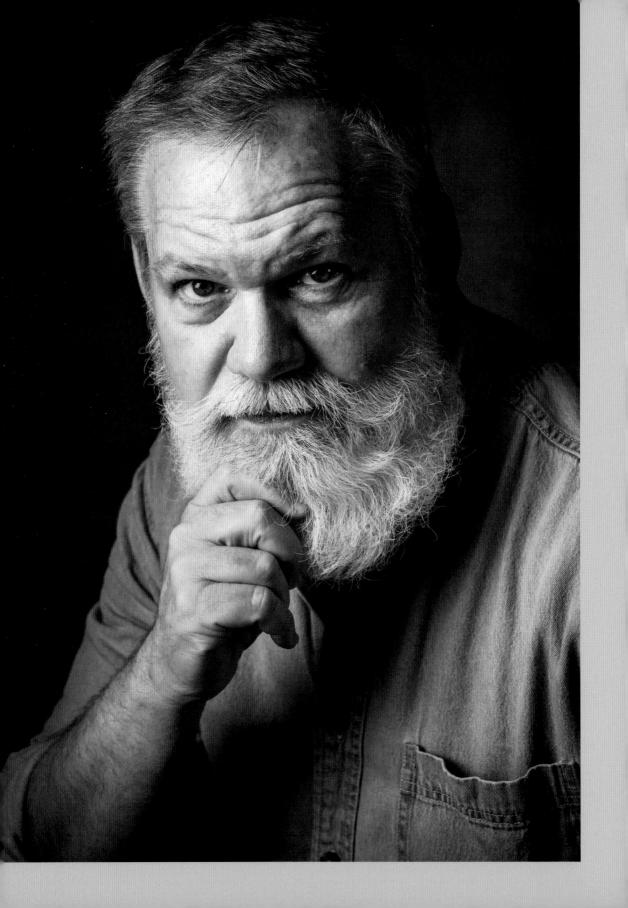

Santa Joseph Patrick Grady does extensive volunteer work with pet therapy and has been testing therapy dog teams for more than ten years. He has a golden retriever who is a therapy dog.

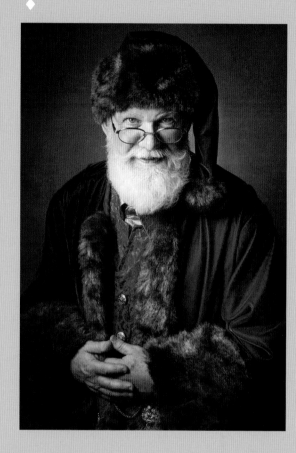

Joseph Patrick **GRADY** b. 1958

LOCATION
Asheville, North Carolina

OCCUPATION
Sales and community service specialist

Dennis **GRAVITT** b. 1955

LOCATION
Cumming, Georgia

OCCUPATION
Electrician, construction
business owner

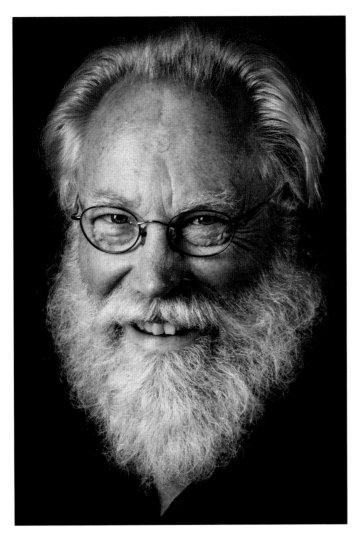

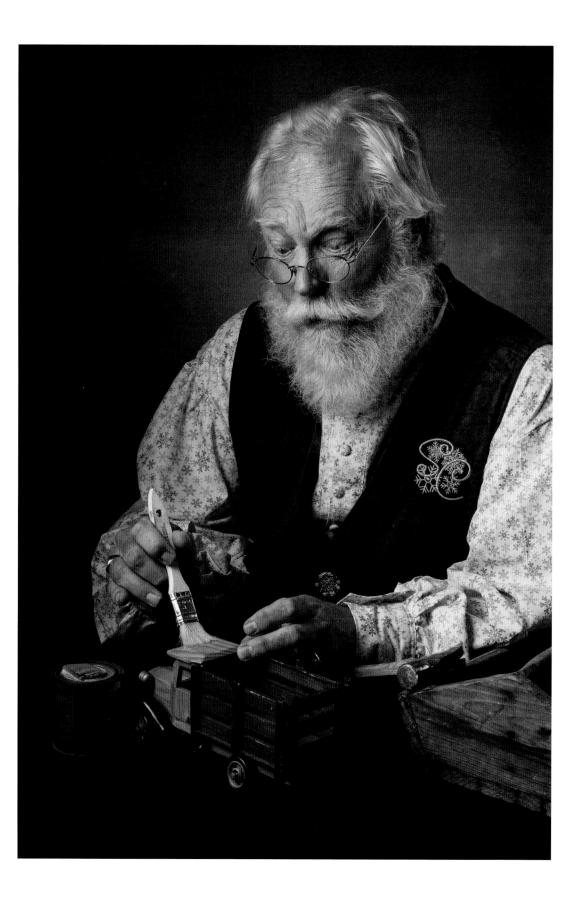

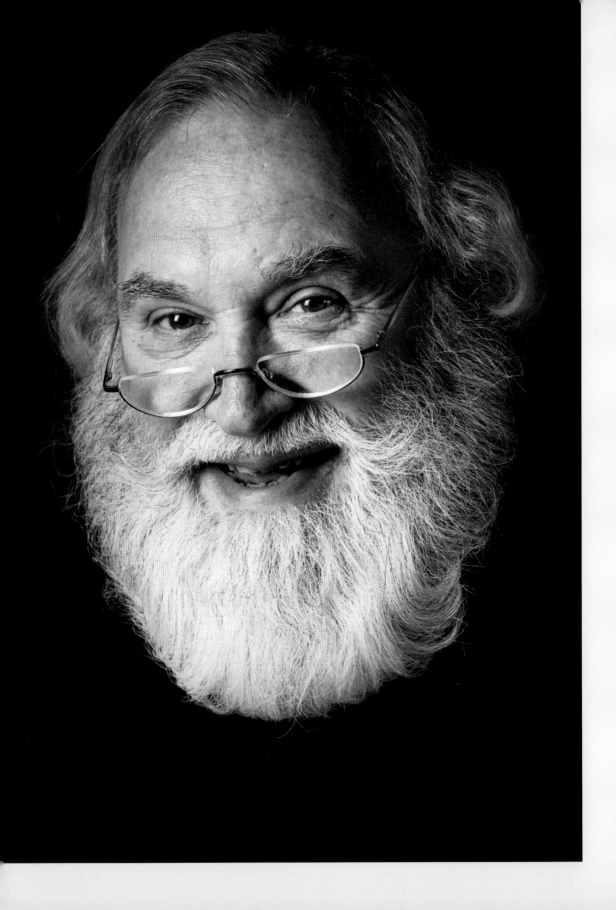

James S. **HARPER** b.1950

LOCATION
Cleveland, Georgia

OCCUPATION
CEO, Georgia Baptist
Children's Home (retired)

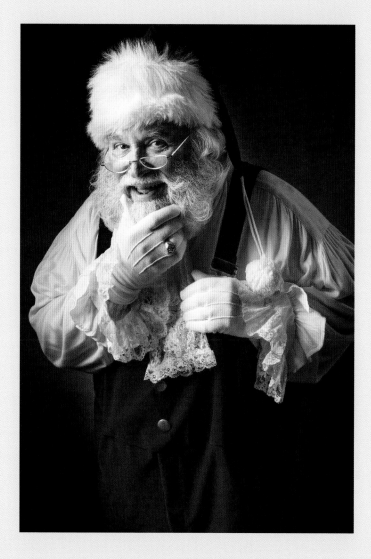

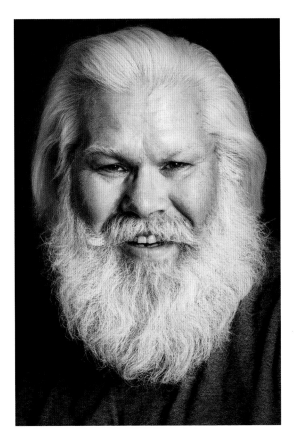

Santa Russell Hurd is a talented bagpiper who plays Christmas carols on his pipes while wearing his Scottish kilt-themed Santa suit.

Russell J. **HURD** b. 1970

LOCATION
Royce City, Texas

OCCUPATION
Sergeant, US Army (retired)

68

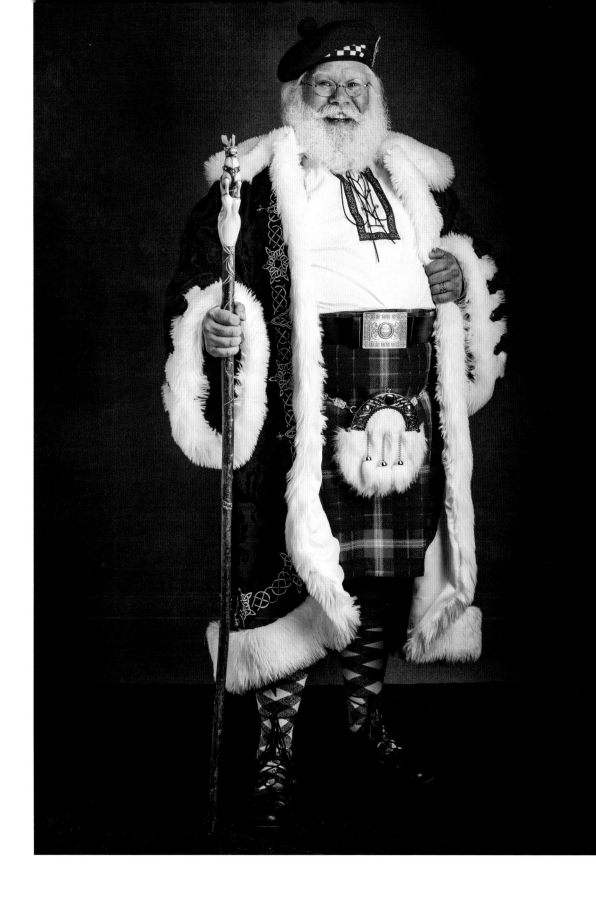

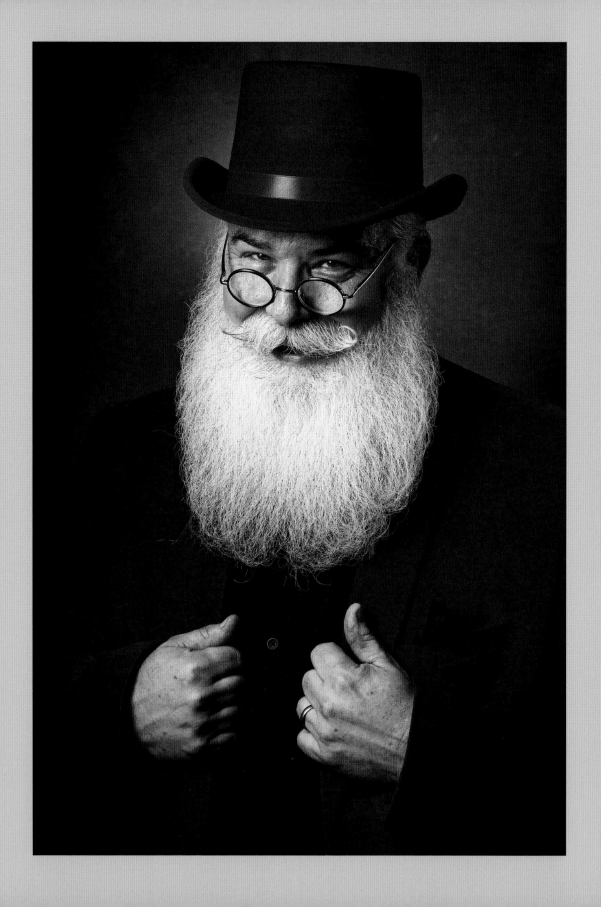

Kenny **HYDOCK** b. 1961

LOCATION
Suffolk, Virginia

OCCUPATION
Project management specialist, US Coast Guard

"This is the most enjoyable thing I've ever done. I never grow weary of it. I want everyone I meet to experience and feel the same hope, love, and joy that I have in my life."

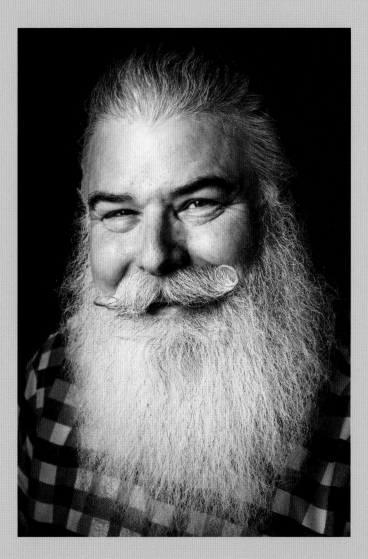

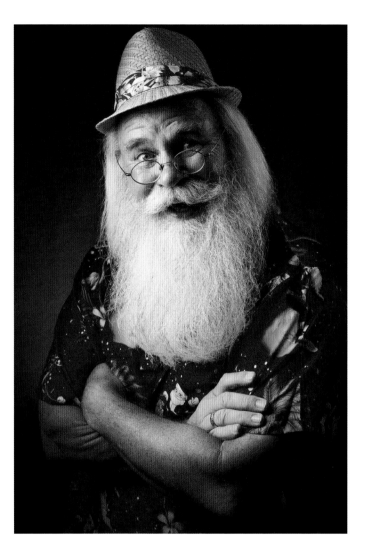

Richard W. **HYMAN**, Sr. b.1946

LOCATION
Snellville, Georgia

OCCUPATION
US Foreign Service (retired),
Federal Aviation Administration (retired)

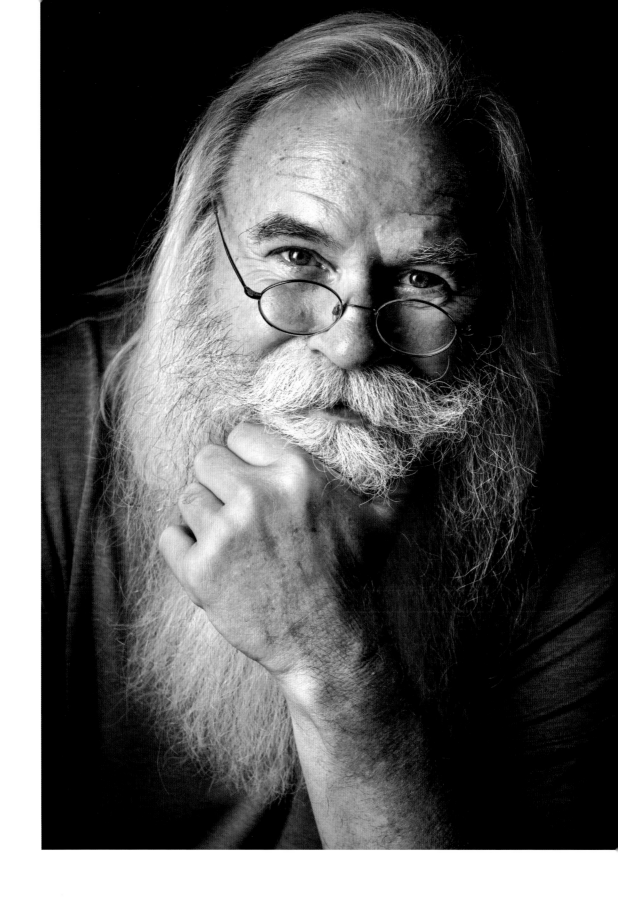

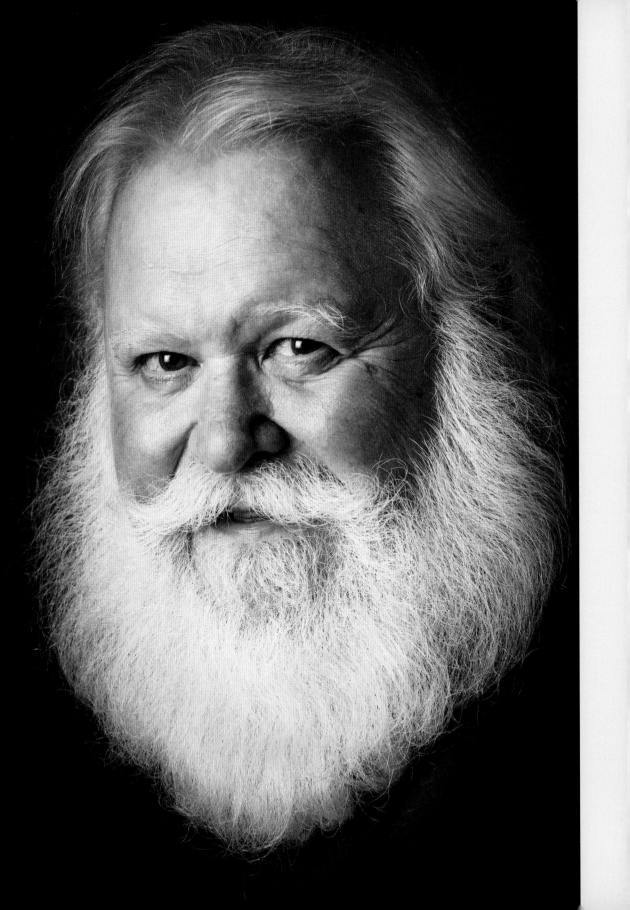

Gary **IDEN** b. 1951

LOCATION
Arlington, Virginia

OCCUPATION
Healthcare imaging specialist

"I get the most satisfaction when I see children run back to their parents and beam to them that 'He is the real Santa.'"

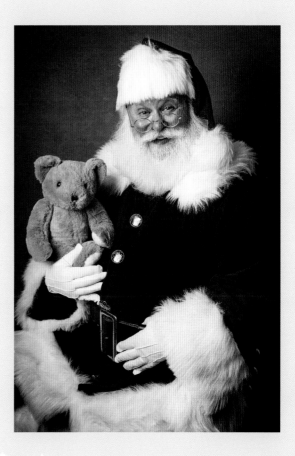

"And the Beard on His Chin Was as White as the Snow"

———

Santa's beard is his most distinctive feature, and becoming Santa often involves entering a new and exotic world: the hair care aisle. For many, growing a beard is the start of their journey—let's not forget that the International Brotherhood of Real Bearded Santas (IBRBS)* boasts more than two thousand members. But even for older men, natural hair color varies, so living up to the white-bearded image in "'Twas the Night Before Christmas" takes work…and often bleach.

Santa Rick Rosenthal says achieving the right look required him to adopt a whole new approach to personal grooming. "I have three or four shampoos and seven or eight conditioners. I used to just dry my hair with a towel and run my fingers through it until I was in my forties. Now I style my hair, I curl my moustache—that takes up to fifteen minutes. When you bleach

*see pp. 144–145

your hair or beard, you can burn your scalp and chin if you don't know what you're doing."

Santas who don't have natural beards have their own set of challenges. High-quality theatrical beard, wig, and mustache sets made of human or yak hair are available to so-called "designer bearded Santas," but prices for professional sets can start at $1,500! Although membership in the IBRBS is limited to those with natural beards, better-quality designer beards allow a more diverse range of aspiring Santas to pursue their calling.

Fred **IMHAUSEN** b. 1950

LOCATION
Indianapolis, Indiana

OCCUPATION
Engineer, real estate broker,
auctioneer

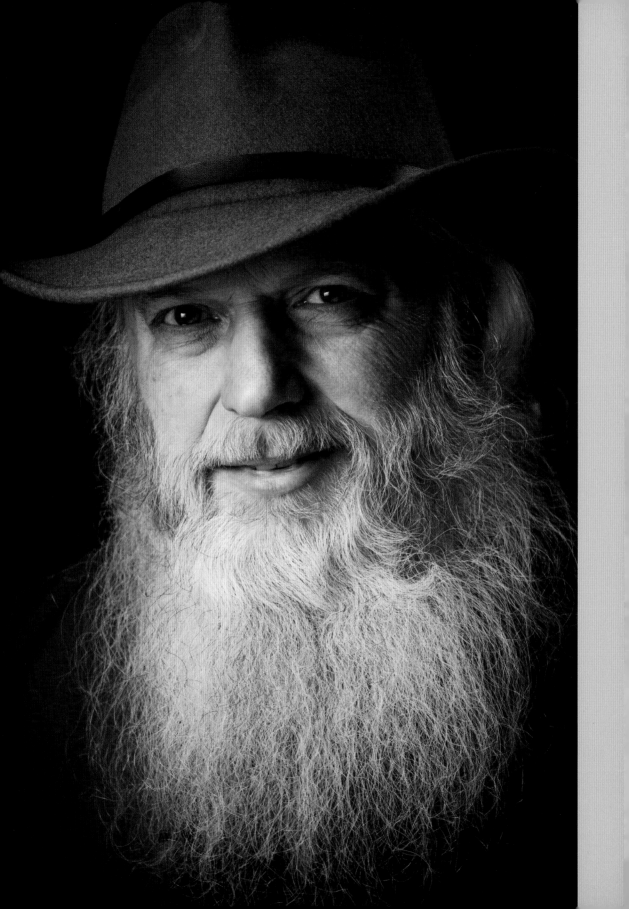

Charles M. **JACOBS** b.1959

LOCATION
Thornton, Colorado

OCCUPATION
Government, US Army, construction

"Don't just put on a Santa suit and say you are Santa. The appearance does count, but it is the mindset that one must have to really be Santa. It is caring for the children that you talk to. It is true that you only have a minute or two with each child, but each visit is special to that child. Each visit has to come from the heart."

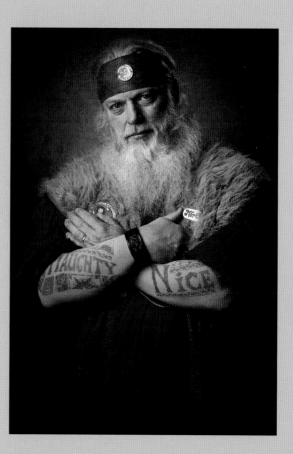

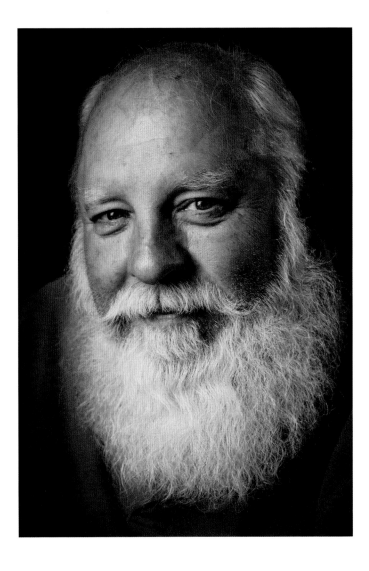

Cesar **JANEIRA** b. 1959

LOCATION
Acworth, Georgia

OCCUPATION
Landscaping business owner

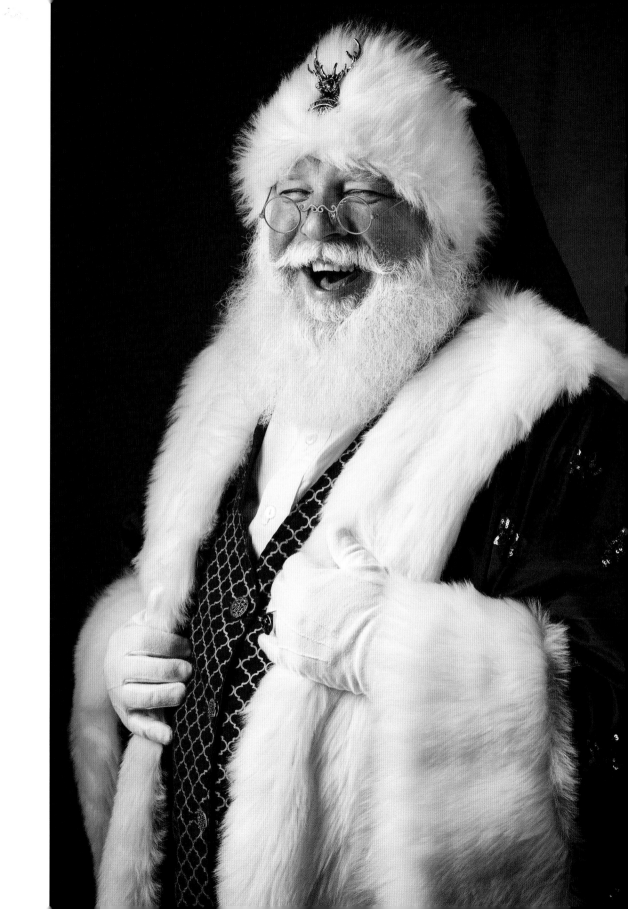

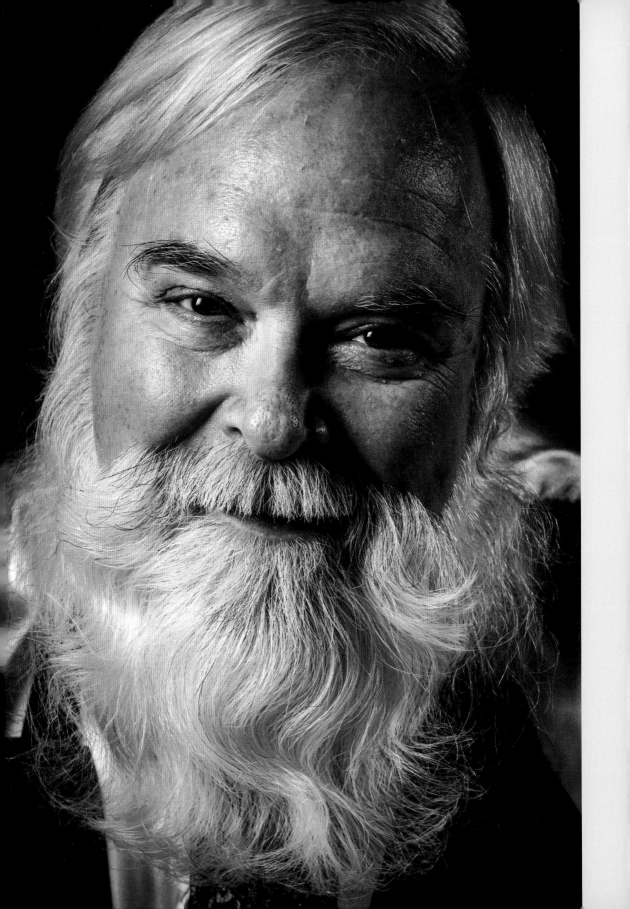

Carl **JOHNSON** b. 1959

LOCATION
Milton, Georgia

OCCUPATION
Retail sales

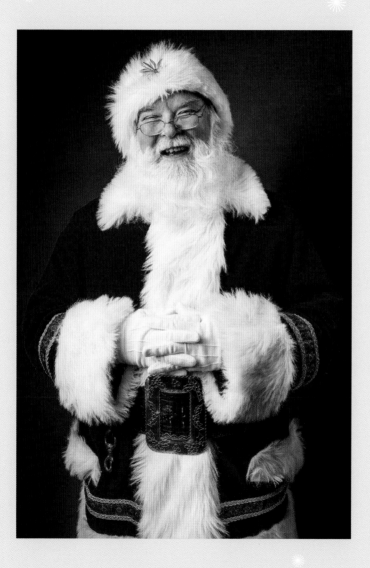

Joel **LAGRONE** b. 1962

LOCATION
Keller, Texas

OCCUPATION
Aerospace engineer,
musician, actor

*"I've tried forty years
to be a rock star.
Santa IS a rock star."*

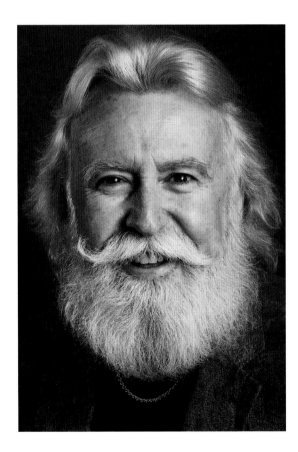

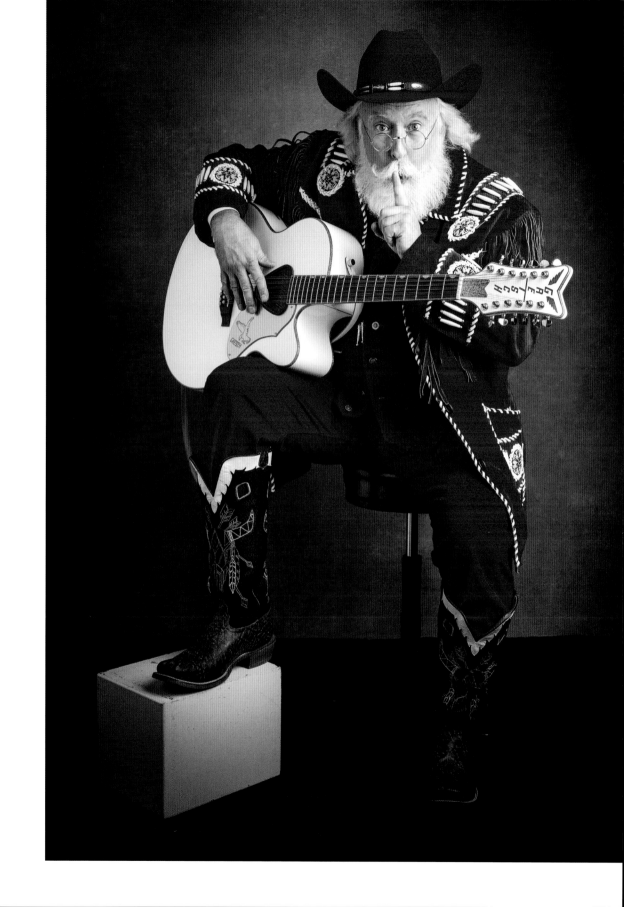

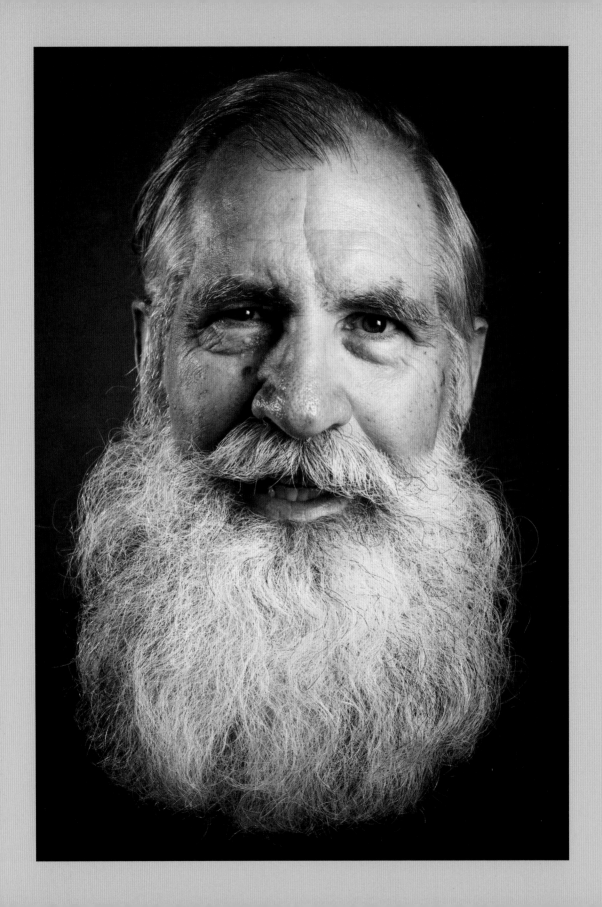

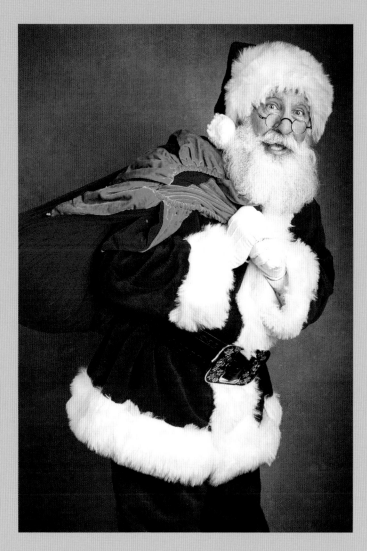

Michael **LAWS** b. 1954

LOCATION
Grand Prairie, Texas

OCCUPATION
Fire marshal (retired)

David **LEWIS** b.1952

LOCATION
Dallas, Texas

OCCUPATION
Engraver, developer,
mentor, trainer

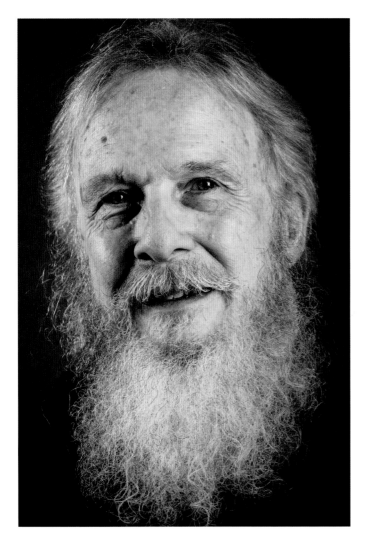

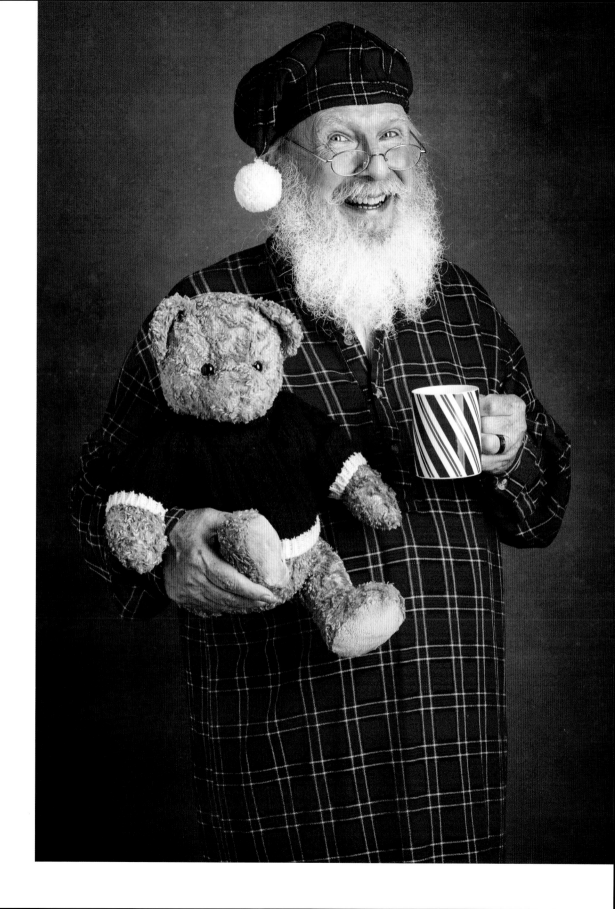

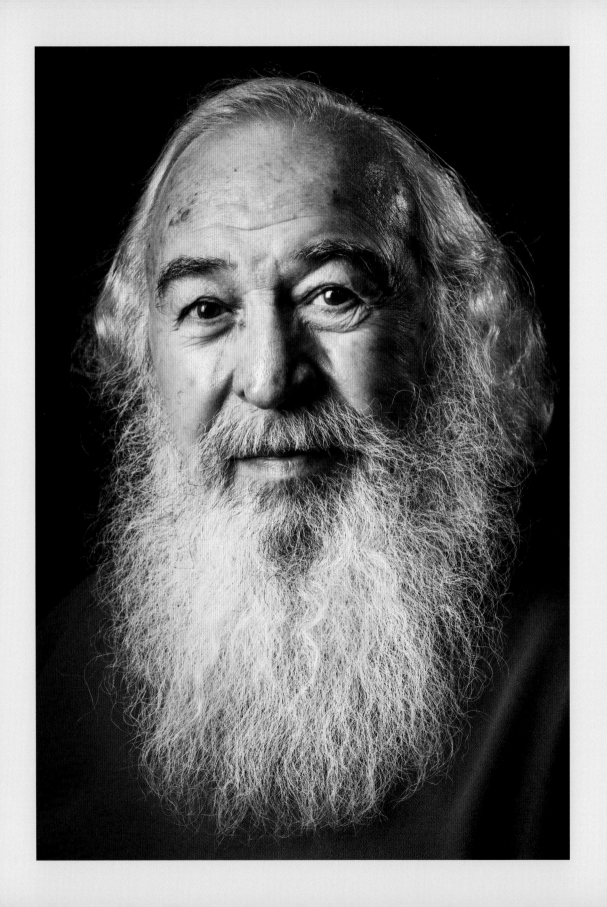

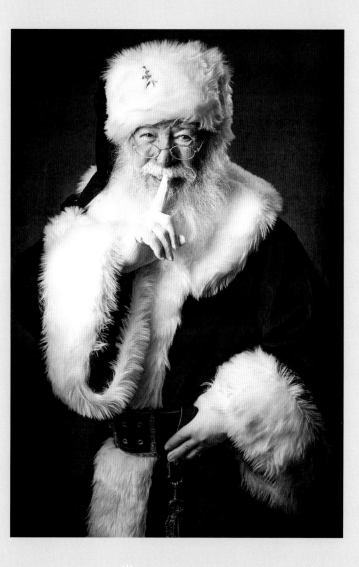

*"It's not the suit.
It's the heart."*

Stephen **LUCERO** b. 1946

LOCATION
Arvada, Colorado

OCCUPATION
Trainer, technology industry (retired)

Richard William **MALE** b. 1949

LOCATION
Spotsylvania, Virginia

OCCUPATION
Electronic technician, National Oceanic and Atmospheric Administration

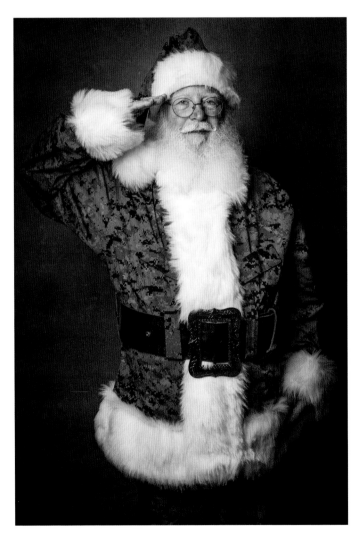

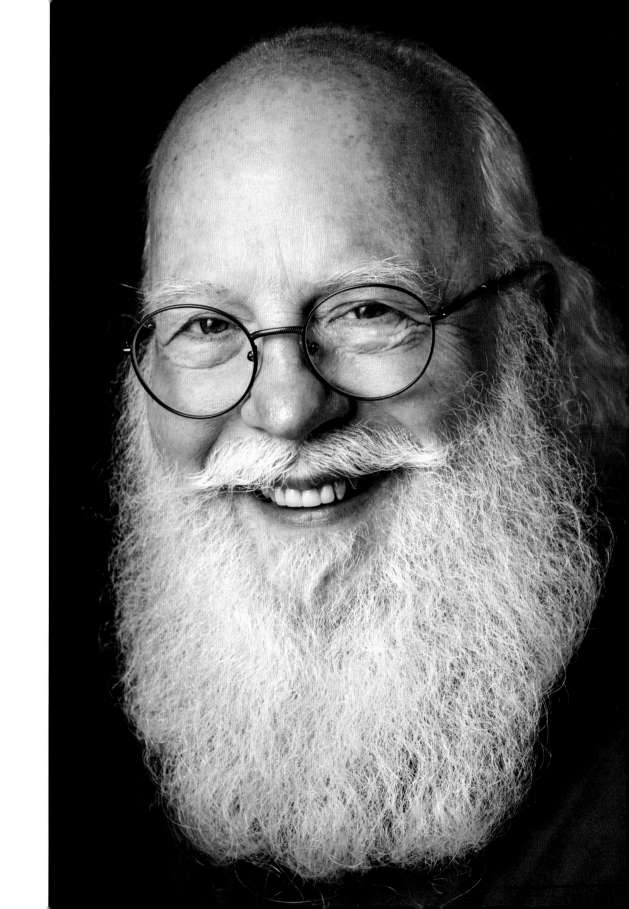

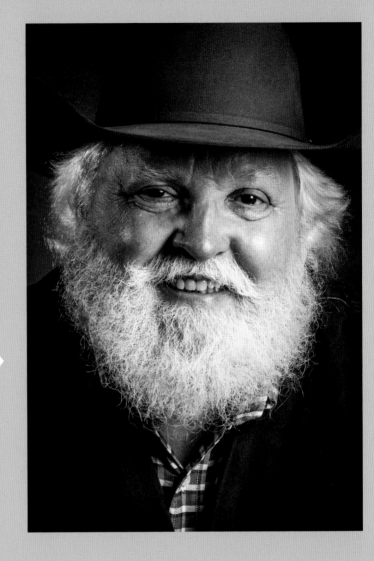

Bill **McELYEA** b. 1959

LOCATION
Weatherford, Texas

OCCUPATION
Long-haul truck driver, beekeeper

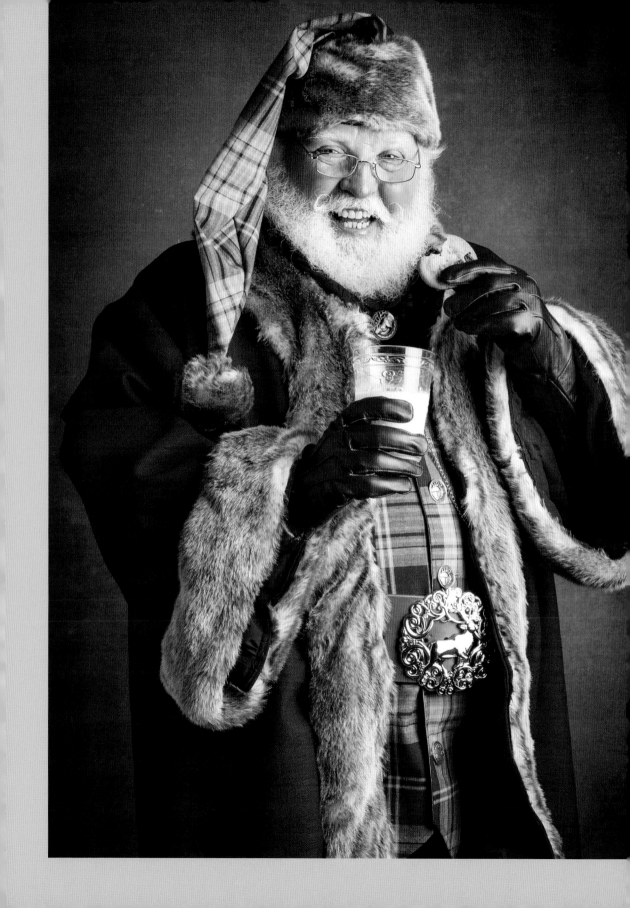

What Do You Want for Christmas?

B efore the season starts, Santas familiarize themselves with toy manufacturers' new releases so that they're ready to speak knowledgeably about children's most likely requests. But there are always surprises. These are some of the items children have requested from the Santas pictured here:

★ a metal detector
★ a vacuum cleaner
★ rainbow eyelashes
★ a purple mattress and purple sheets
★ a coffin bed
★ a burrito

More proof that Santas can't always anticipate trends in children's requests: "One season, three different children in three different locations asked for real helicopters," reports Santa Craig Stone. Santa Gary Iden recalls a little boy who wished for the complete works of Mel Tormé (Mom, looking on, said Santa should think of her son as a sixty-four-year-old man inside the body of an eight-year-old).

Of course, not every child asks for something that Santa's sleigh can deliver (as evidenced by the helicopter requests). Multiple Santas have received requests

for unicorns, while one little girl "wanted me to send Rudolph to her so she could take care of him till next Christmas," says Santa Mike Tindall. Amphibians are also popular: one child asked for a singing frog, while another wished that Santa would turn his sister into a frog!

Then there are children with more worldly preoccupations: the fourteen-year-old girl who asked Santa Garth Scovill for Justin Bieber, or the twelve-year-old boy who asked Santa Stephen Lucero for underarm hair to help him keep up with his older brothers. One kid wanted his own bathroom—no more sharing with the rest of the family!

Sometimes a child just wants to chat. Santa Doug Eberhart has been asked about food allergies and whether his cookies needed to be gluten free, while Santa John Fuller recalls one visitor who blew in his face and asked, "What does my breath smell like?" And then there are the real showstoppers—like the five-year-old boy who told Santa Michael Chapman he wanted to return the present he got last year. He had wanted a puppy, but instead his parents brought home a baby sister.

Finally, there are the wishes that warm the heart. As Santa Ward Bond says, "One of my favorite requests is when the oldest child, who may not be a believer, asks for everyone else to have what they want for Christmas. It always gives me hope for the future."

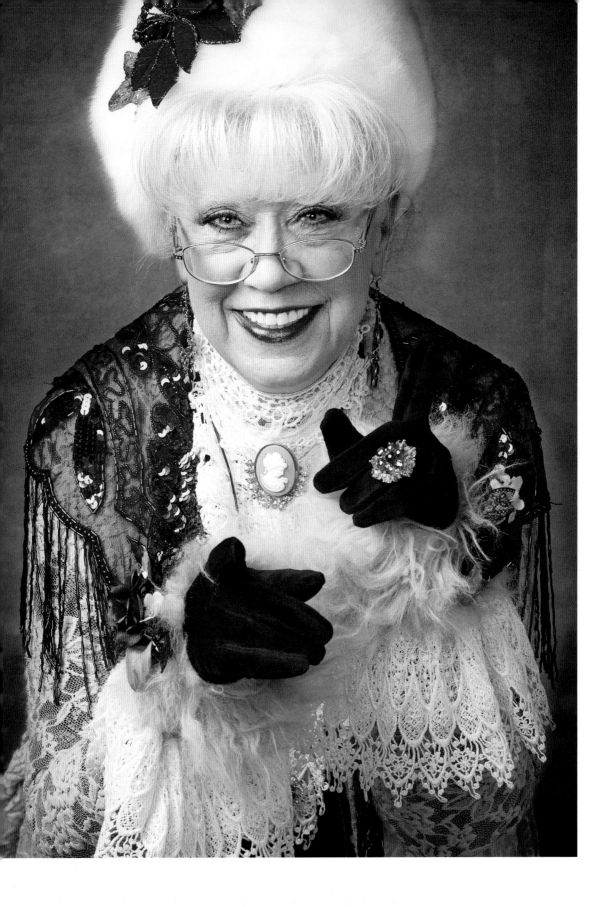

Susen **MESCO** b.1957

LOCATION
Lafayette, Colorado

OCCUPATION
Founder and director,
Professional Santa Claus School,
Santa agent

By definition, the Santa trade is a male-dominated field. That makes **SUSEN MESCO**'s success in the world of Santa especially impressive. She never set out to make Christmas her business. Instead, she started out as a teacher and then got into sales. A job with a souvenir photo franchise led her to event planning, which, in turn, led to hiring Santas for shopping malls. Four malls the first year became fourteen within three years.

Mesco's early market research consisted of watching mall Santas on the job, and she quickly noticed room for improvement. "The Santas were cranky, the children were crying, the moms were upset, and it was just horrid. I thought there had to be a better way," she says. To ensure that she was delivering the most professional Santas to her mall customers, Mesco developed a training program in 1983, which she taught in her living room to the four Santas she represented. Within a year, the student roster grew to eighty. Since then, Mesco's Professional Santa Claus School has trained more than twenty-five hundred Santas and Mrs. Clauses. Mesco's other business, American Events, represents hundreds of Santas who do mall appearances, home visits, video chats, parades, and other events.

What made a young female entrepreneur think she could take charge of a roomful of Santas? "My dad told me there's nothing you can't do," she says. "They saw that what I had to say had substance. I earned their respect. It became a synergy of, 'this is what we're going to do together.'" In 2019, Mesco was inducted into the International Santa Claus Hall of Fame, one of the few women to have been so honored.

Mesco also finds time to appear as Mrs. Claus. At one party for a group of foster children, she got to know Hazel, a four-year-old who begged to go back to the North Pole with Mrs. Claus and Santa. It took a lot of convincing before the child let go of her plan and started working on a tree ornament at the party craft station instead. Hazel covered a ball—and her hands—with white glue and glitter, and presented her dripping creation to Mrs. Claus with a big glitter-and-glue hug. Despite many repeat cleanings, some glitter remains in a seam of Mesco's Mrs. Claus sleeve. "It reminds me that's the reason we do what we do," she says. "In this world, so many of us don't have safe places where we can go and know it's going to be OK. Santa is the last hope of having a hero. I want to guard this tradition."

Thomas L. **MYERS** b. 1952

LOCATION
Frisco, Texas

OCCUPATION
Records and information,
management consultant

After retiring from his career as a corporate records manager, Thomas Myers wanted to get involved in activities where his full beard would be an asset, like performing. An accomplished storyteller and ventriloquist, he now works year-round as a children's entertainer. At Renaissance fairs, he performs as a wizard with owl and dragon puppets. He's also active in the Single-Action Shooting Society, whose members dress in nineteenth-century Western attire and compete with period weapons in events that include an annual reenactment of the shootout at the O.K. Corral.

But Myers's cowboy and wizard adventures are second to being **TEXAS STAR SANTA**. "I've always been a big Christmas Village and ornament collector, and I've had a full beard for more than thirty years, so being Santa was a natural shift as my beard became whiter," he says. He also notes a career connection: "I specialized in records management—Santa's been doing that for centuries."

He went to his first Santa school in 2003, and continues to attend school and Santa gatherings. Among many valuable lessons, his training taught him how to be a little larger than life. "With the beard, it's hard for people to see you smiling. Santa's smile has to be bigger— you have to smile with your eyes," he says.

After completing his training, Santa Tom debuted at a Phoenix shopping mall. He recalls one memorable week when parents of a newborn brought their five-day-old infant to see Santa on their way home from the hospital. That special experience was then followed a few days later when he met a 105-year-old woman who wanted a picture with Santa for her great-granddaughter. "It's amazing to me that the things children say are the same things you hear from seniors. Everyone remembers Santa Claus. It's their oldest memory," he says.

Every holiday season since 2012, Santa Tom and his Polar Puppet Pals have offered staged Santa experiences to audiences of fifty to a hundred children at private and corporate events. He tells stories with full-size puppets that include Brr the polar bear, Jingles the elf, Rudolph, and Mini-moose, a Rudolph wannabe with a magnetic red nose. Then he meets with children one-on-one, using hand puppets—a baby polar bear, a mouse, and a weasel—that help put shy or frightened children at ease.

Santa Tom sees some children year after year and takes note as they gradually grow less anxious about meeting with Santa. "It's the ones where you can feel you're breaking through that mean the most," he says. The most important thing he keeps in mind: "Being there with the child in the moment—listening to what they have to say, and just being there for them."

John H. **NICKLES** b. 1949

LOCATION
Van Alstyne, Texas

OCCUPATION
**Fire marshal (retired),
college instructor**

James B. NUCKLES b. 1947

LOCATION
Decatur, Georgia

OCCUPATION
**US Army (retired),
US Government (retired)**

A week before Christmas 2006, James Nuckles was at the mall
on an errand for his wife when the mall's Santa recruited him to start
performing as **SANTA JAMES**. He dismissed the idea at first but
eventually reconsidered. He was planning to retire from his work
as a government facilities manager in a year. "I went to Santa school
and came back as a full-fledged Santa," he says. A self-described
lifelong learner, Nuckles still attends Santa school every year. "You
can never learn too much," he says. "We should try not to be critical,
but to understand each other. You've learned a million things that
I don't know; I just want to learn some of that."

James Nuckles has always been dedicated to public service.
The retired Army veteran was on active duty for six years in Thailand
and Taiwan. He was in the Army Reserve for twenty-eight years
and is a retired employee of the US government. He earned
a master's degree in religious education and is partway through a
PhD dissertation. Inspired by the life of Saint Nicholas, Santa James
volunteers at local libraries, where he reads to children. "I look on
it as a ministry. That's my reason for being here on earth," he says.
He also visits homeless people in Atlanta's Woodruff Park, where
everyone gets peppermint sticks from Santa. He worked at DeKalb
Mall for four years and now visits private and community parties
in addition to his volunteer work.

Santa James recalls an appearance at Georgia State University, where he was approached by a young woman whose grandmother was in the audience. The elderly woman had confided to her granddaughter that she had never taken a picture with Santa Claus, and now she was trying to get from her wheelchair up to the raised platform where Santa James was situated. "I said, 'Stay where you are,' and went down to where she was. I got on my knees, put my arms around her shoulder, and said, 'Mother, I'm here,' and I told the photographer, 'Snap away.' She said I was the first black Santa Claus she'd ever seen in her whole life!"

"I've had some Caucasian kids say I'm not the real Santa because I'm not white. African American kids, too. Some parents even ask how I got to be Santa Claus if I'm not white. I ask them, 'What color is Santa? How do you know?'" He tells them about Saint Nicholas, who is usually depicted as dark-skinned. "Most of the time they'll take a picture with me. Every now and then they walk away, and that's OK."

Nuckles had a heart attack in 1997, and he says he came through that experience with a new attitude, one that Santa James embodies. "I pray for people all over this world to come to understand that time is short, and we can't get overly hateful, overly mad about anything. A hundred years from now, it won't matter. Just be happy."

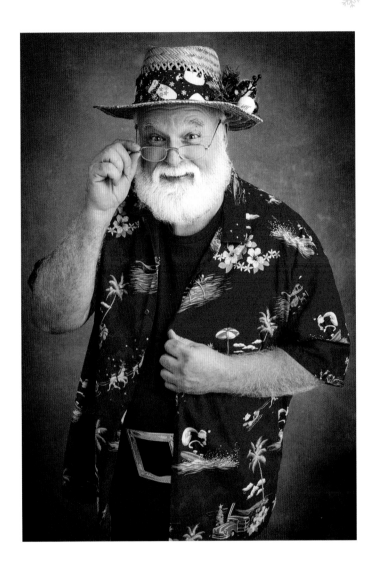

Tyre **OLIPHANT** b. 1960

LOCATION
Houston, Texas

OCCUPATION
Sales representative

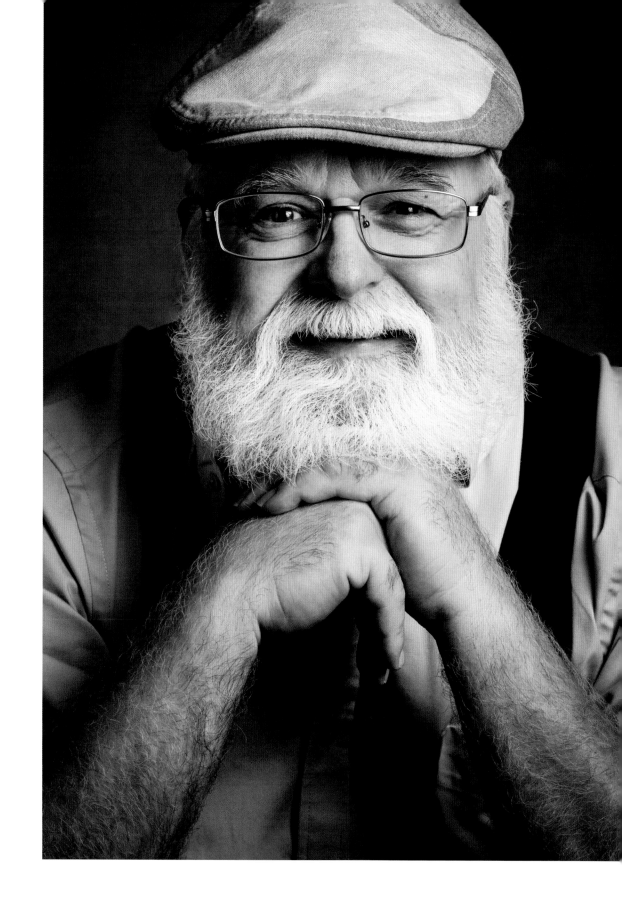

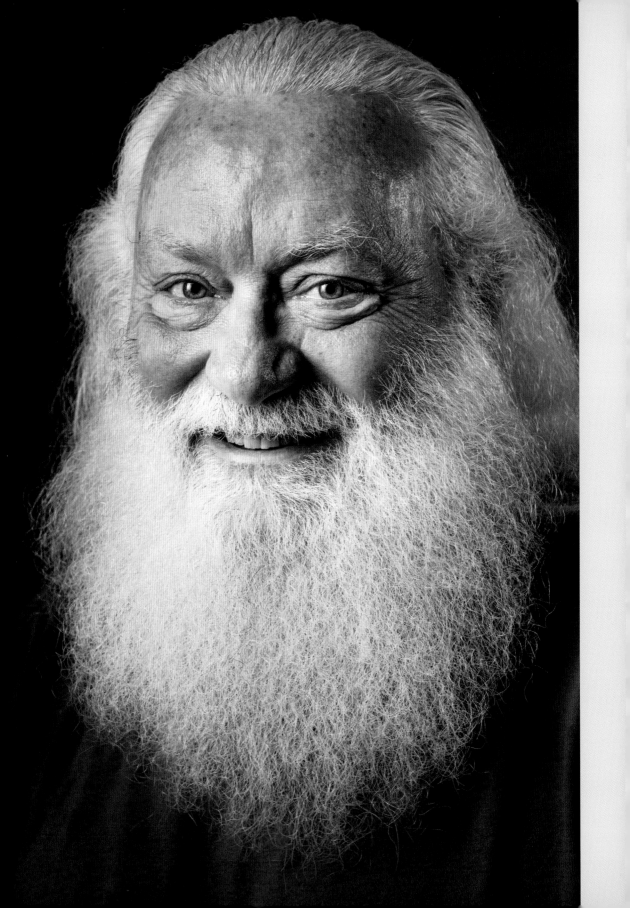

Mark **PETERSEN** b. 1950

LOCATION
Fishers, Indiana

OCCUPATION
Information technology
project manager (retired)

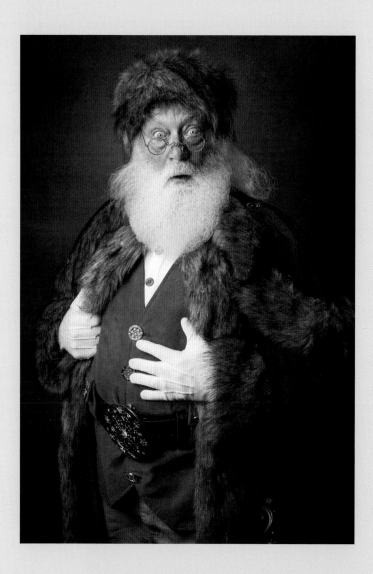

Joe **PRIDGEN** b. 1948

LOCATION
Sugar Hill, Georgia

OCCUPATION
Building contractor (retired)

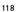

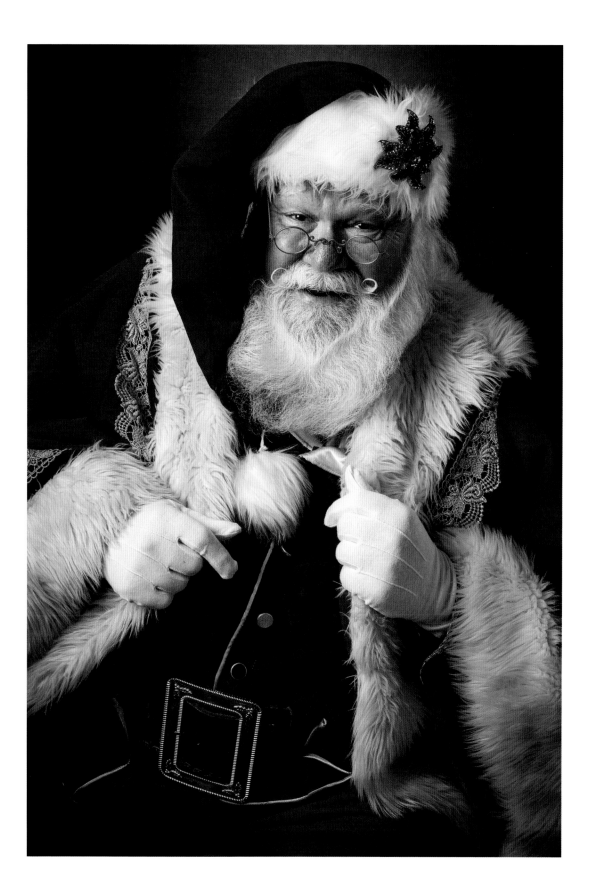

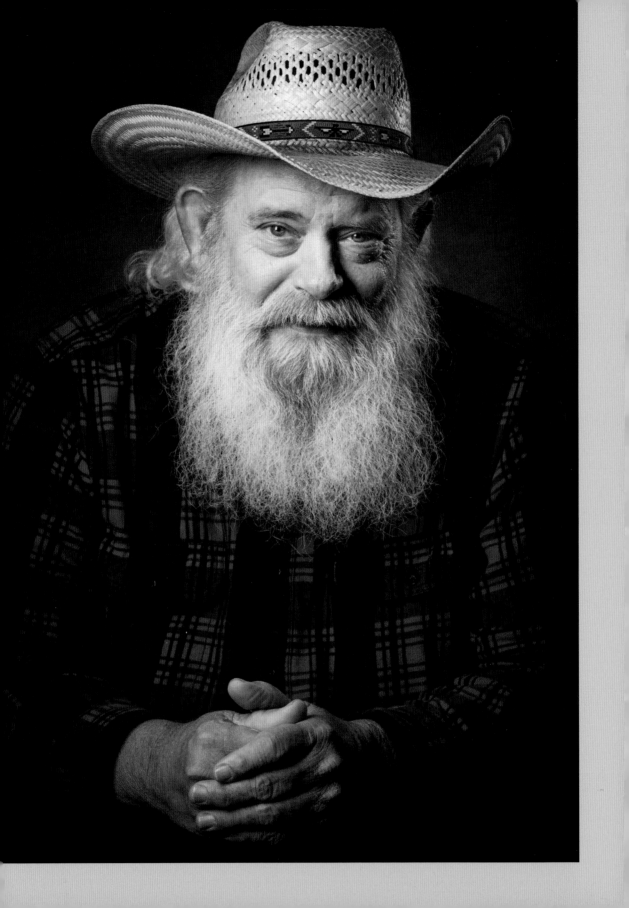

Mark R. **PROCTOR** b. 1952

LOCATION
Fishers, Indiana

OCCUPATION
Land surveyor

"I don't look at being Santa as a job but rather a calling to spread some happiness to everyone I meet."

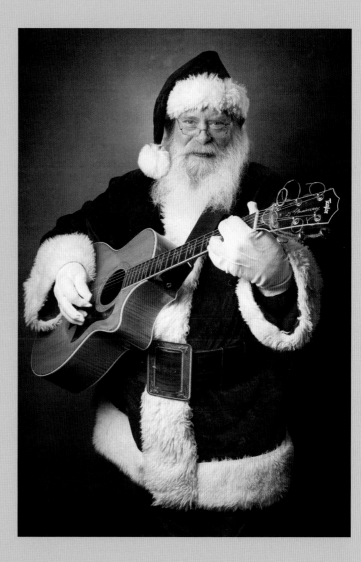

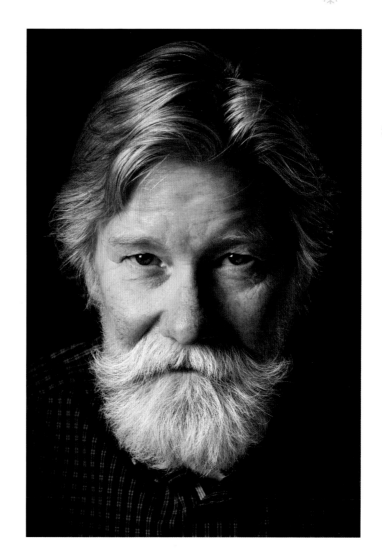

Mason **QUERNER** b. 1952

LOCATION
Colorado Springs,
Colorado

OCCUPATION
Training specialist (retired)

Von A. **REDMAN** b. 1949

LOCATION
Ellijay, Georgia

OCCUPATION
**Public safety official,
sheriff department, fire department**

*"If you want to talk to
Santa, shake the
globe, close your eyes,
and believe."*

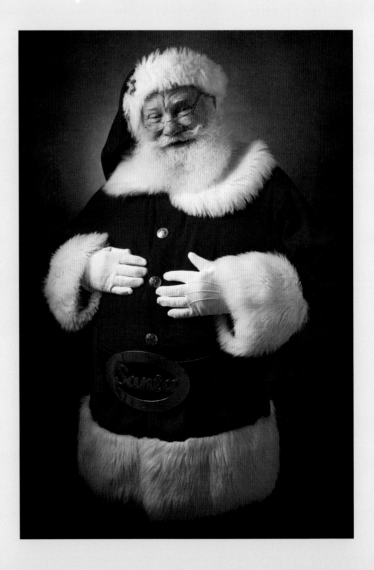

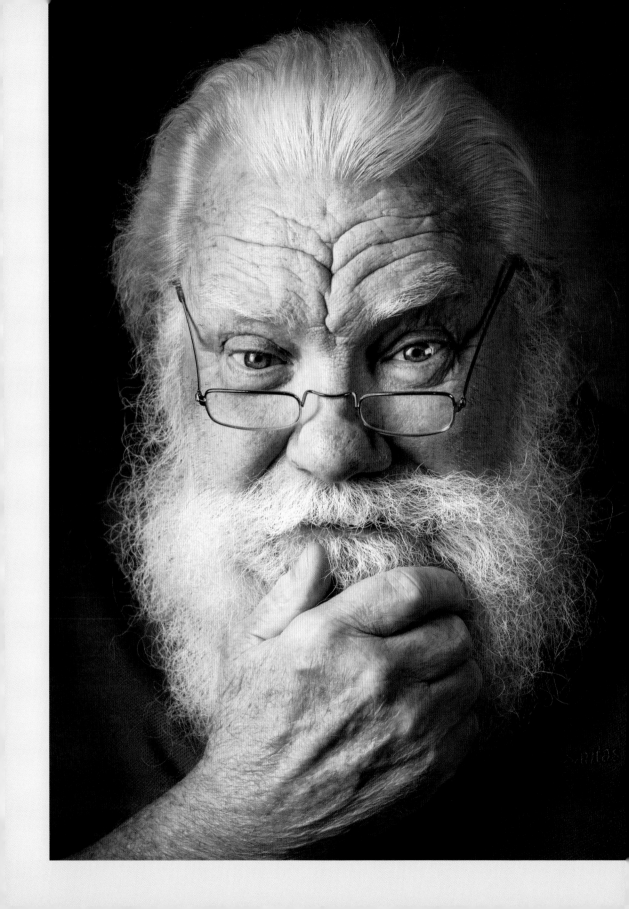

Difficult Requests: Santa's *Third* List

———

Even though he embodies hope and joy, Santa must be prepared to engage on a deep, personal level with visitors who may be in emotional pain. Every Santa can recall a heartbreaking request. It's one thing to explain to a young inquiring mind that Santa's magic is toys, and that's why he can't deliver a unicorn. But how does he respond to a hopeful child who sees Santa as a magical being who might be able to bring a parent home safely from war, or restore a loved one to health, or stop Mom and Dad from fighting?

Within the limits of their immediate circumstances, Santas will often take measures to assist families in crisis. After hearing the child's request, they may refer parents to a social services agency, or encourage them to seek help from their church or their child's school. If abuse is suspected, Santa may urge the child to tell a teacher. When a child told Santa James Nuckles that he was hungry and hadn't eaten, Santa gave his helper some money to buy a meal for the child. "If a child has to ask Santa Claus for food, something's wrong," Nuckles says.

A thoughtful Santa learns to offer children love and reassurance without promising them the impossible. He will acknowledge the child's question and

explain that there are some things that Santa's magic cannot fix. Santa Ward Bond says, "You have to gently let them down in a way that helps them feel you're doing something to support them." He then explains that in addition to his Naughty and Nice lists, Santa keeps another list of people he prays for. He tells the child, "I may not be able to make sure that Grandma is healed [for example], but what I can do is pray with you and add you to Santa's prayer list." Many Santas keep a special notebook on hand in which they record the child's name and request. They will reassure the child that Santa loves them and will be thinking of them. It's a powerful way to give hope to a child who needs it.

No matter how difficult the visit may be, each interaction with Santa lasts for only a few minutes. Santa must learn to recover quickly so that the next child he speaks with has a full, joyous experience. Santa Ward says that after an emotional encounter, he'll step away for a moment to compose himself and "rise above the moment. I know that right now, even though I'm feeling sad, I can use that [experience] as a tool to overcome, knowing that I helped nurture that child."

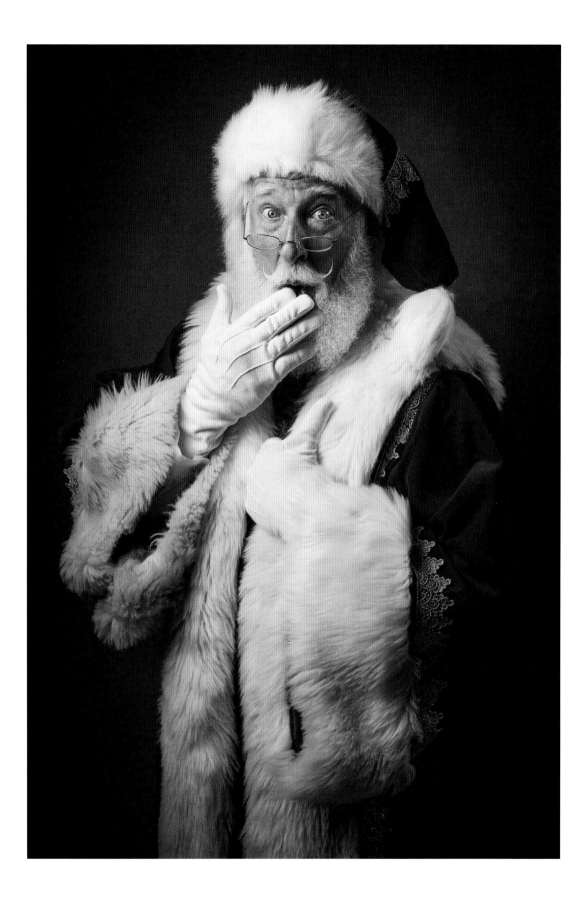

Rick **ROSENTHAL** b. 1952

LOCATION
Atlanta, Georgia

OCCUPATION
**Entrepreneur, owner/dean of
Northern Lights Santa Academy, Santa agent**

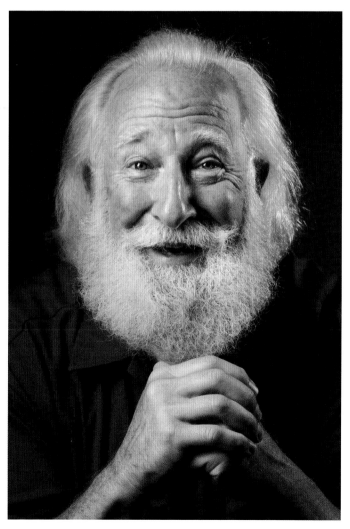

Rick Rosenthal, an Orthodox Jew, has been **SANTA RICK** for fifty years, but while he started dressing up casually in high school, it wasn't until much later that he began to take the role more seriously. In 2011, when both of his parents died, Rosenthal observed the Jewish tradition requiring men in mourning to stop shaving for at least thirty days, and up to a year. His calling came several months later on a shopping trip to Home Depot. Still fully bearded, he noticed a little boy holding his father's hand who wouldn't stop staring at him. "I realized he recognized me as Santa," Rosenthal said. "I told him not to tell anyone he saw me buying tools for the elves. I knew at that moment that I would keep my beard and be Santa all year round." Since 2012, he has committed to being Santa all day, every day. Appropriately enough, the career entrepreneur coincidentally lives on Merry Lane in a Christmas-themed subdivision of his native Atlanta.

Santa Rick remembers a five-year-old boy who asked for a trampoline. Not a standard trampoline, but a tiny one: holding his thumb and forefinger apart, he showed Santa he wanted a trampoline about two inches in diameter. When Rosenthal asked why, the boy's mother stepped in to explain that her younger son had died. The miniature trampoline was for the boy's brother. "The mom was crying," says Rosenthal, "but this little boy was happy as he could be. As Santa, you don't make promises, because you don't know what a child's reality may be. But I told him, 'I'm going to talk to the elves, and we'll make this a priority. And I've never flown my sleigh that high, but I'm going to see if we can make it up to heaven and bring your brother that trampoline.'"

Rosenthal believes that Santa is completely unique. "If you see Santa, on a subconscious level, you'll feel better. He's the only person who has that effect. Nothing in this world, human or otherwise, is like Santa, and I have to honor and respect that position. There's no bigger responsibility—it needs to be protected." His philosophy: First, love yourself. Then love others without judgment. When in doubt, he asks himself, "What would Santa do?" He's serious about

Santa being for children of all ages. "Everybody is somebody's child," he says. "Seven-foot-four basketball players sit on my lap."

In addition to appearing as Santa across the United States and Canada year-round, Rosenthal is an agent for holiday performers and the dean of Northern Lights Santa Academy. Opened in 2016 with sixty-five students, the school now hosts up to two hundred aspiring Santas and Mrs. Clauses in each of its two yearly sessions. He teaches his students not to be Santa for financial reward or even for their own amusement. "It's not about you, it's about the children," he says. "It's about their innocence and hope."

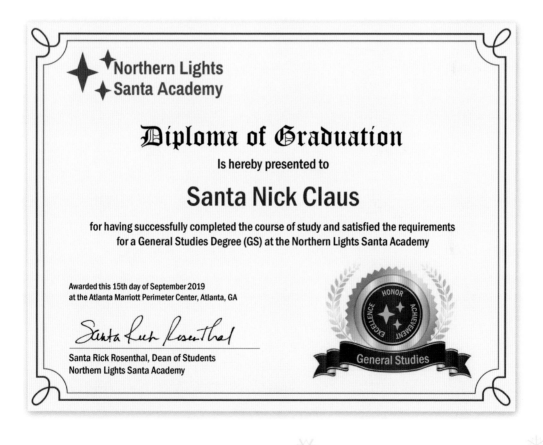

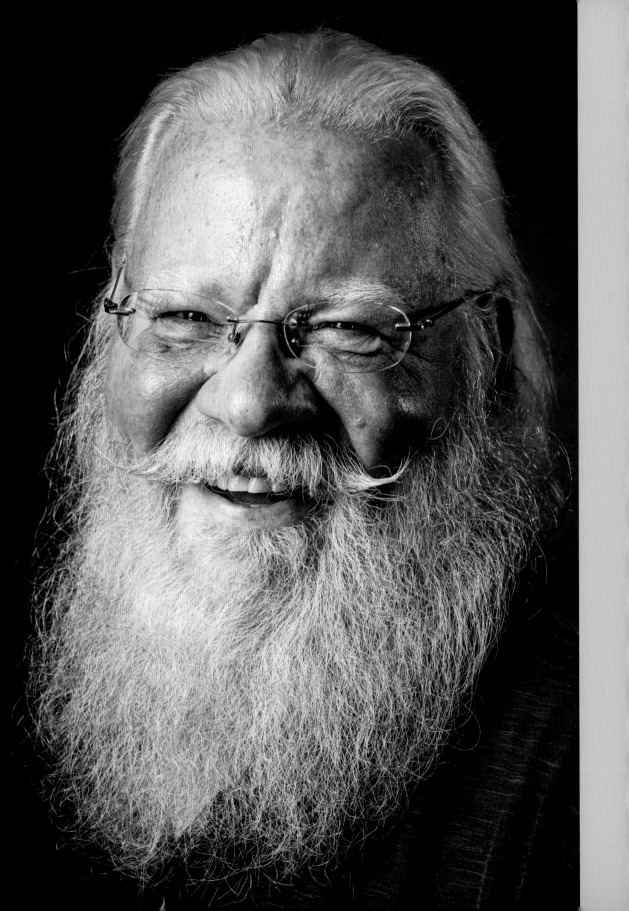

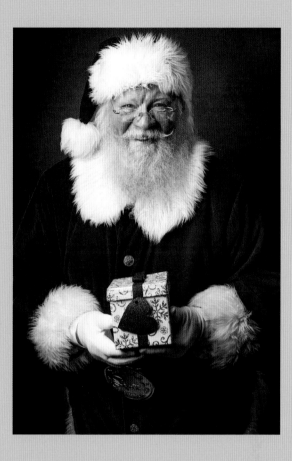

"My grandfather, dad, and uncles were all Santas. My uncle was a pro Santa for Macy's."

Frank **ROUSE** b. 1959

LOCATION
Indianapolis, Indiana

OCCUPATION
Building materials sales

Garth **SCOVILL** b. 1954

LOCATION
Parker, Colorado

OCCUPATION
Manager, telecommunication industry,
business owner, entrepreneur

*"It seems like I've always
been the Santa that I am.
Who I am as Santa is
the same as me without
the suit, only my mischief
is tolerated better when
I'm wearing red. I expect
I'll be buried in my
Santa suit."*

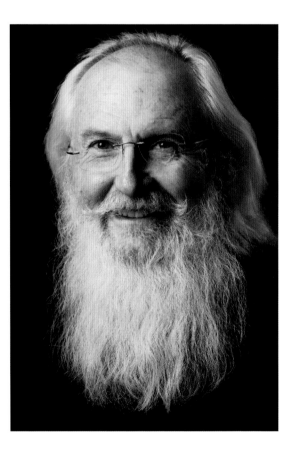

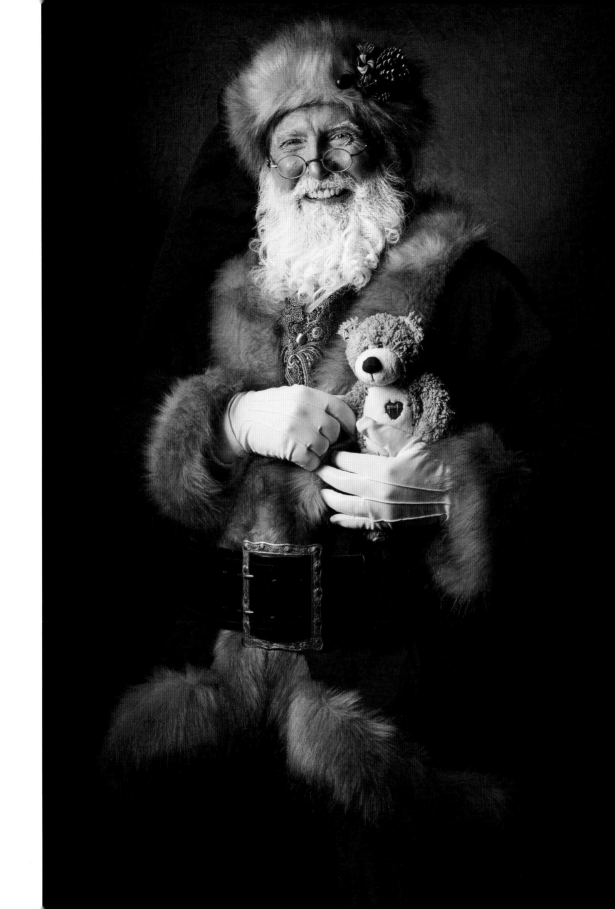

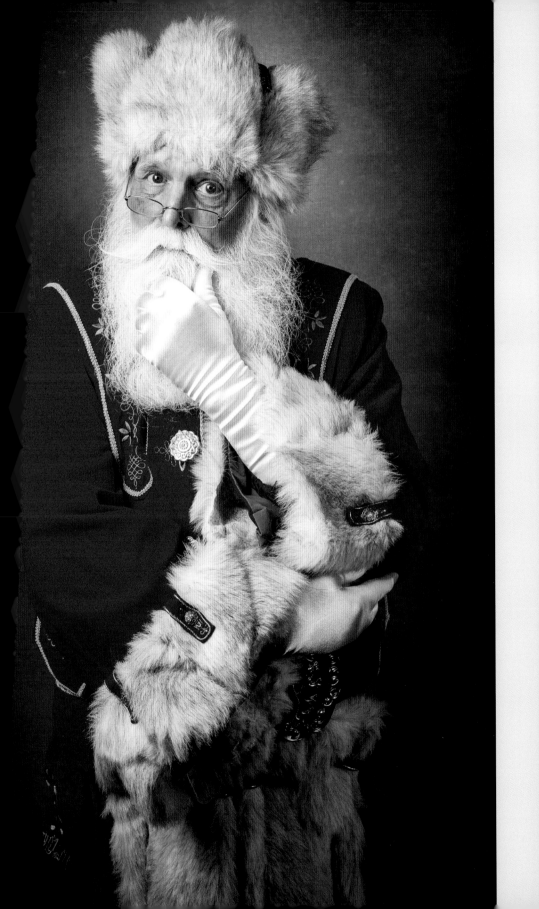

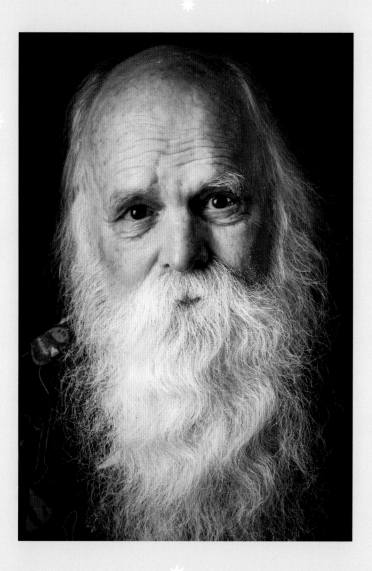

Larry **SHAW** b. 1949

LOCATION
Indianapolis, Indiana

OCCUPATION
Letter carrier, US Postal Service
(retired)

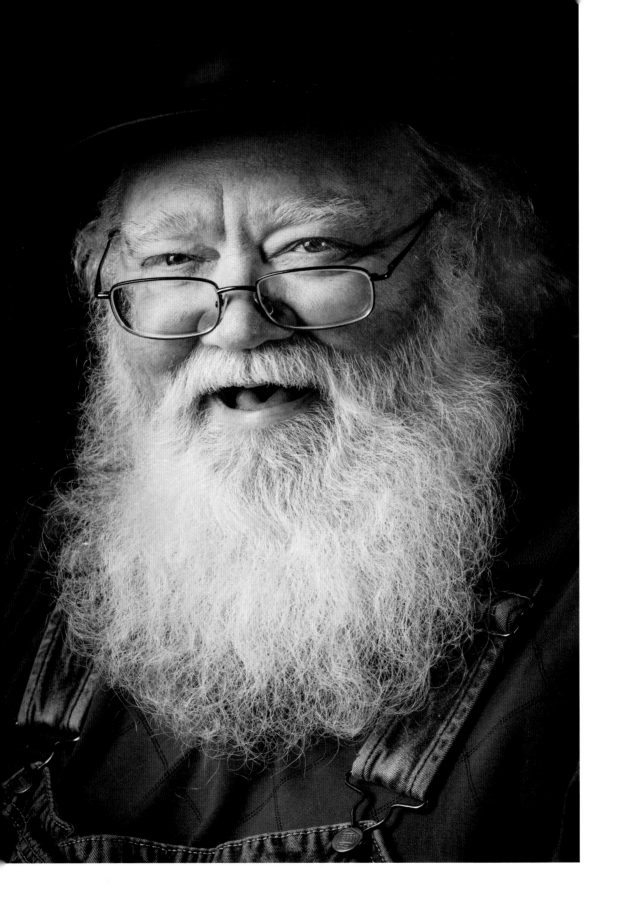

Woodrow Wilson **SMITH** III b.1969

LOCATION
Soperton, Georgia

OCCUPATION
Emergency medical technician

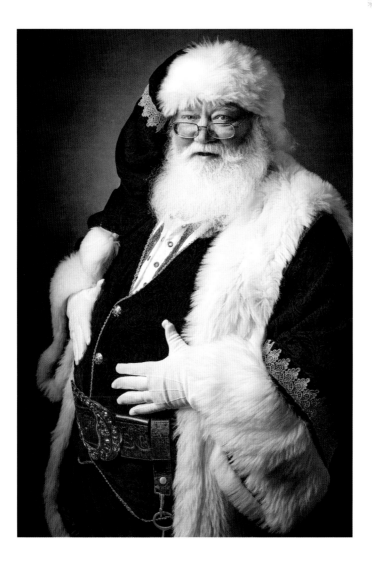

Santa Craig Stone is a professional magician and has performed across the United States, on cruise ships, and at the world-famous Magic Castle in Hollywood.

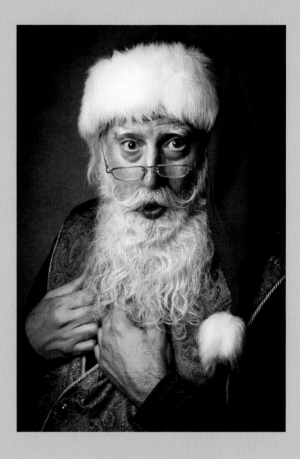

Craig **STONE** b. 1958

LOCATION
Indianapolis, Indiana

OCCUPATION
Professional magician

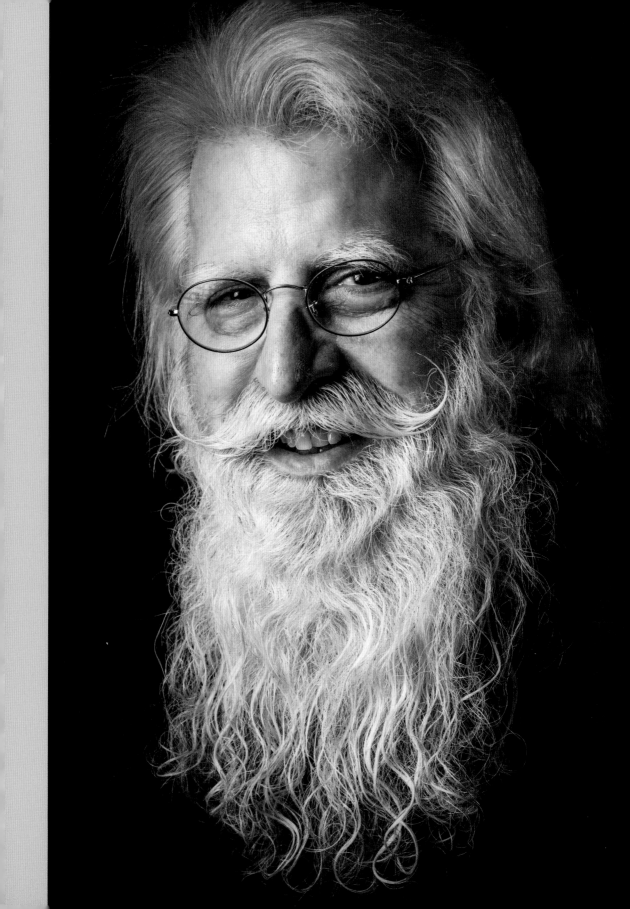

Barry **SWINDALL** b. 1955

LOCATION
Burleson, Texas

OCCUPATION
Letter carrier, US Postal Service (retired)

Santa Barry Swindall wears a patriotic suit with white stars on a blue field. It is fashioned after one depicted in the 1863 Thomas Nast illustration "Santa Claus in Camp," in which Santa is seen visiting Union soldiers during the Civil War.

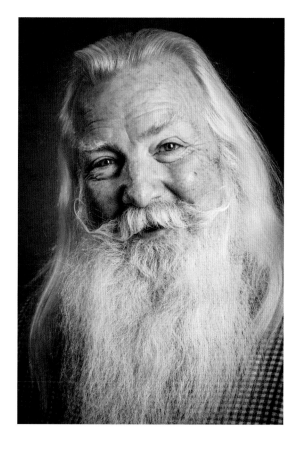

IBRBS / The Santa Claus Oath

(International Brotherhood of Real Bearded Santas)

———

Our Mission

To keep Christmas magic in the hearts of children of all ages by creating an international Christmas community.

Our Tenets

❄ We uphold the magical spirit and meaning of Christmas.

❄ We promote the joy of giving.

❄ We respect the diversity of Christmas traditions throughout the world.

❄ We uphold the positive image of Christmas performers.

❄ We are aware of the impact and effect of our appearance at all times.

❄ We support the principles embodied in the Santa Claus Oath, the Mrs. Claus Pledge, and the Elves' Oath.

❄ We foster good will and cooperation throughout the entire Christmas Community.

❄ We encourage members to participate in charitable and volunteer activities in their communities.

❄ We promote a safe environment for all.

❄ We will do nothing to embarrass the Christmas Community and the IBRBS organization by our conduct, in word or deed.

Our Motto

SUPPORT • SHARE • INSPIRE

Dedicated to Jim Yellig and Charles W. Howard

———

I will seek knowledge to be well versed in the mysteries of bringing Christmas cheer and good will to all the people that I encounter in my journeys and travels.

I shall be dedicated to hearing the secret dreams of both children and adults.

I understand that the true and only gift I can give, as Santa, is myself.

I acknowledge that some of the requests I will hear will be difficult and sad. I know in these difficulties there lies an opportunity to bring a spirit of warmth, understanding and compassion.

I know the "real reason for the season" and know that I am blessed to be able to be a part of it.

I realize that I belong to a brotherhood and will be supportive, honest and show fellowship to my peers.

I promise to use "my" powers to create happiness, spread love and make fantasies come to life in the true and sincere tradition of the Santa Claus Legend.

I pledge myself to these principles as a descendant of St. Nicholas the gift giver of Myra.

—Phillip L. Wenz

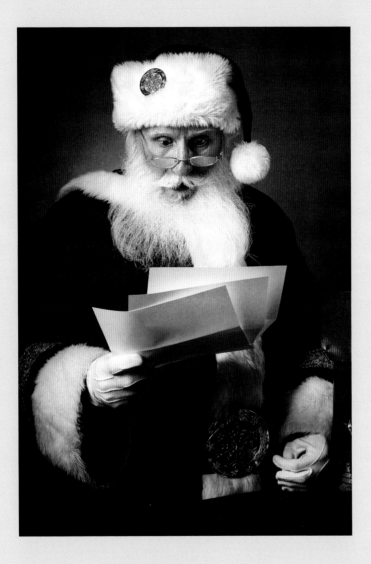

Michael E. **TINDALL** b. 1953

LOCATION
Atoka, Tennessee

OCCUPATION
US Navy (retired),
aviation mechanic

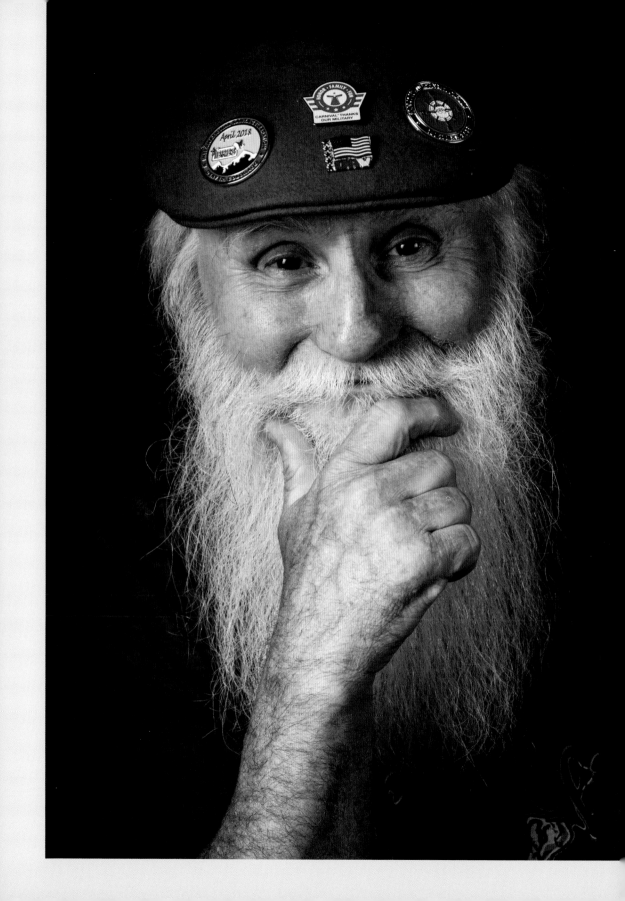

A Navy veteran who served for twenty-two years as an aviation machinist, Mike Tindall was stationed on an aircraft carrier in the Red Sea and the Mediterranean during the Gulf War. He spent twelve years at sea, retired as a Navy chief in 1995, and now works full-time at FedEx as an aircraft reliability analyst. Every year, starting in mid-November, his days are crammed as full as Santa's bag of toys. He's up at four in the morning and heads to his day job at FedEx. Then, mid-afternoon, SANTA MIKE changes into his red suit and drives to a Memphis-area Bass Pro Shop, where he holds court from three to eight in the evening. On weekends, he logs five to six hours a day as Santa at private parties and events.

Santa Mike and his wife, Cindy, have also been raising and homeschooling three of their six grandchildren, now in their teens. Santa activities are often family affairs, with the grandkids on elf duty and Cindy serving as Mrs. Claus. The couple had been working occasionally for a few years but got serious about their mission in 2010, when they attended Northern Lights Santa Academy in Atlanta. There, Santa Mike learned about storytelling from experienced professionals, while Mrs. Claus learned "things that Santa doesn't know" to enhance her own visits with children. "Little ones may be nervous about Santa, but they'll go to Mrs. Claus," Santa Mike says.

Training also emphasized for Tindall the importance of how he conducts himself when he's off duty. Despite his medium-size frame, he says that with his full beard, "I'm Santa all year long. If I didn't have my beard, it would be different, but kids recognize me as Santa wherever I go, whatever I wear. If you do something you shouldn't do out in public, it leaves a bad impression. That hurts the whole Santa community." Being smaller than his namesake's iconic image doesn't get in Santa Mike's way, although Cindy has to alter his red suits. He doesn't wear padding: "I used to stuff, but I don't like it. It's more the adults that notice than the kids. A lot of Santas have started to slim down for health reasons."

Another physical consideration that hasn't slowed Santa Mike down is the 1994 loss of his hand in a woodworking accident. He now has a fully functioning prosthetic "like the Terminator's" and plays in North American One-Armed Golfer Association tournaments. His most memorable encounter was with a shy six-year-old

who was nervous about meeting Santa. After the little girl agreed to sit on his knee, Santa Mike noticed that she didn't have a left hand. "I looked at her mom and gave her a wink and said, 'Let me show you something.' I pulled up the sleeve of my jacket and shirt and knocked on my arm. Her eyes got big and she threw her arms around my neck. It was the highlight of my season. That's why I am Santa," he says.

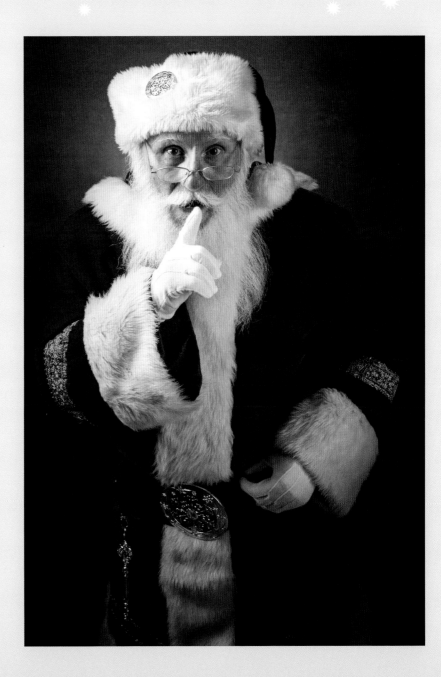

Douglas Noel **VANDECAR** b. 1956

LOCATION
Sugar Hill, Georgia

OCCUPATION
General Motors (retired)

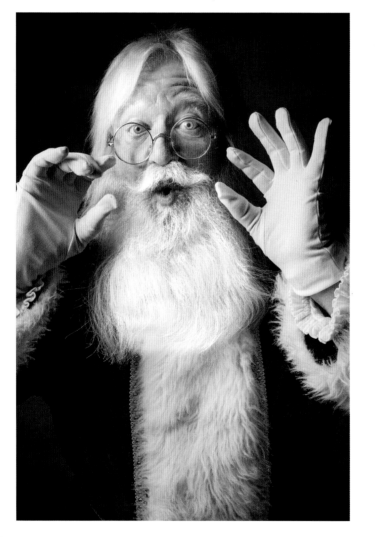

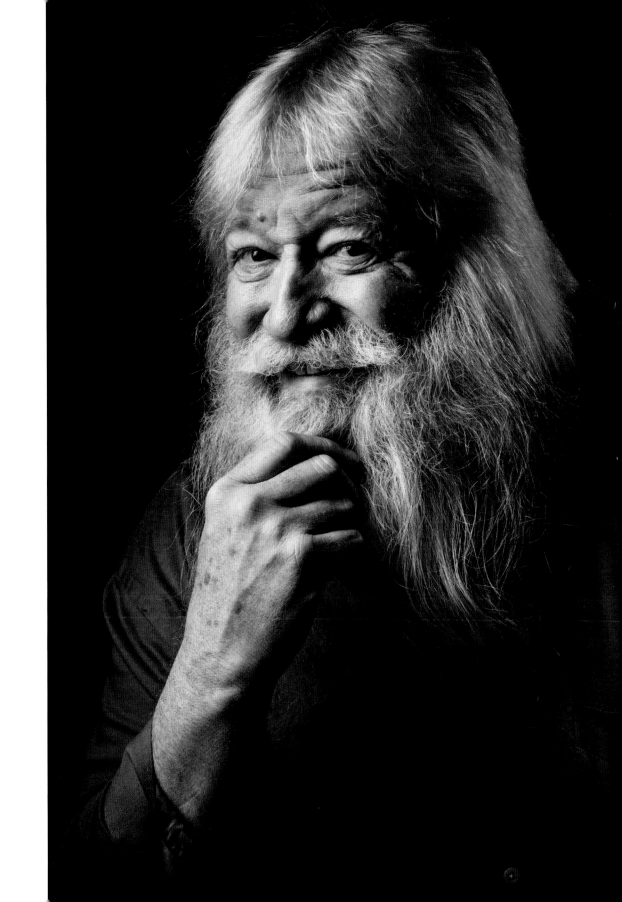

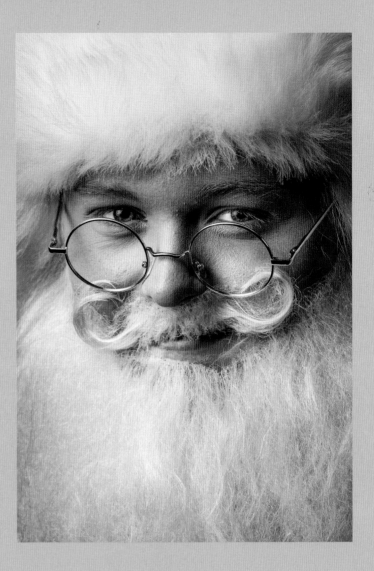

SANTA HUNTER SINCE 2003

Hunter **WOODSON** b.2000

LOCATION
Arrington, Virginia

OCCUPATION
Plumber

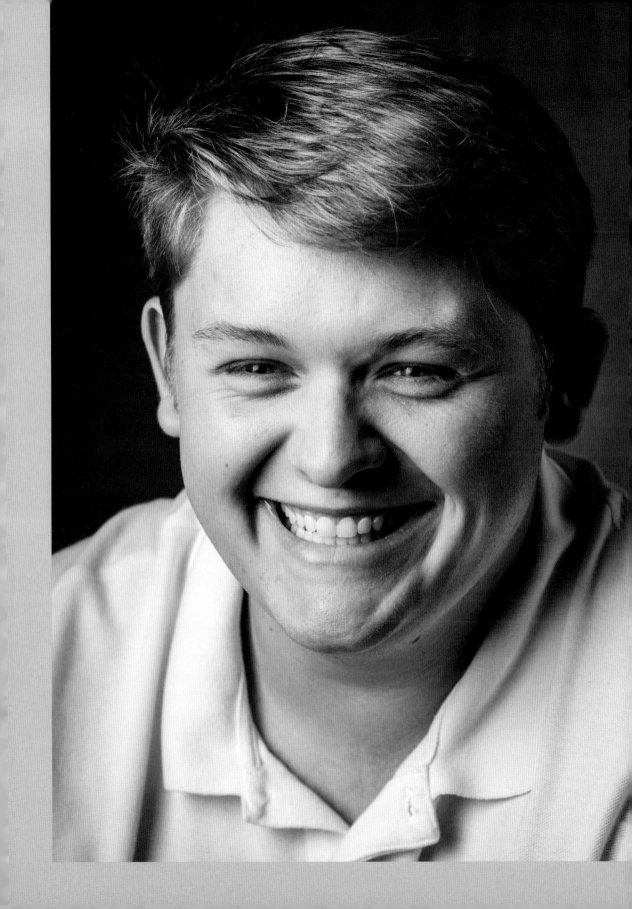

At age nineteen, Hunter Woodson already has many years of Santa experience under his young belt. He had put on a red hat and pretended to be **SANTA HUNTER** when he was only three. When the holiday season rolled around, his great-grandmother sewed white trim on a child's red jogging suit and got him a too-big fake white beard. His great-grandfather owned a small country store, and Hunter became a holiday fixture there. "I wore the beard for three years until it fit," he recalls. At thirteen, Woodson began to take the job seriously. He was Christmas shopping with his family and saw a Santa suit at Party City. He spent his birthday money on the suit, and "that opened up a door to a whole new world." He learned a bit about the Santa community and began saving—not for a car or laptop like so many of his peers—but, instead, for a professional suit from Adele's of Hollywood.

When the president of the Parent Teacher Organization for Woodson's school called him at home, his mother assumed her son was in trouble. Instead, Woodson was asked to perform as Santa at a "Breakfast with Santa" event. Up to that point, he says, "I didn't know much about what Santa should do other than say 'ho-ho-ho' and 'What do you want for Christmas?'" One child who attended the event asked Santa to bring her father back home from his deployment in Africa. Santa Hunter was at a loss for how to respond, so he decided he needed an education to help fine-tune his Santa skills. He attended the International University of Santa Claus to learn more about his craft, and he continues to meet regularly with mentors. At fourteen, he bought the $650 Adele's suit he'd been saving for.

When he's not Santa, Woodson works as a plumber in his family's business. The family is fully supportive of his calling, giving him time off to be Santa when needed. He thinks he may someday grow a real beard, but he's clean-shaven for now. "I enjoy being Santa, but I enjoy being myself, too," he says. Meanwhile, his Santa earnings help cover his costs, including $1,500 for a professional-quality wig and beard. The suit and hair work a kind of magic. "Regular Hunter goes away and Santa Claus comes. I'm not Hunter, the kid who plays Santa Claus. When I put on the suit, I am The Man," he says.

Santa Hunter's motivation is simple. "It's a whole lot of fun to see kids' eyes light up. The stories you can tell and the wonder you create is magical. They're usually nervous at first, then they warm up. The younger children, a year old to two or three, you don't know whether they're gonna laugh, or cry, or spit up. It keeps you on your toes. But when you get a kid that truly believes, you can tell."

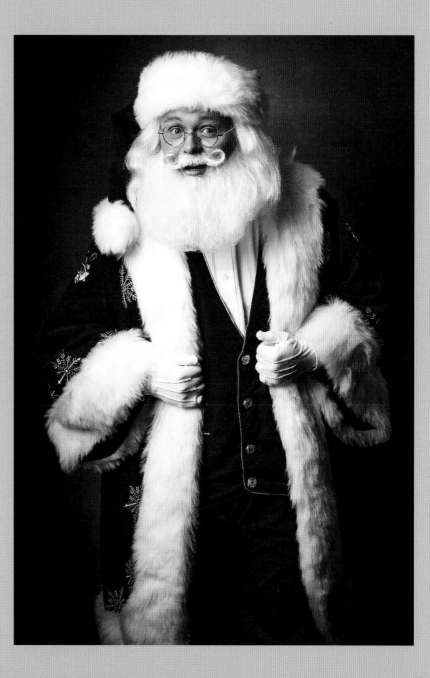

Stephen F. **YURASITS**, Jr. b. 1951

LOCATION
Mountain View,
Arkansas

OCCUPATION
Maintenance manager, nuclear
power industry

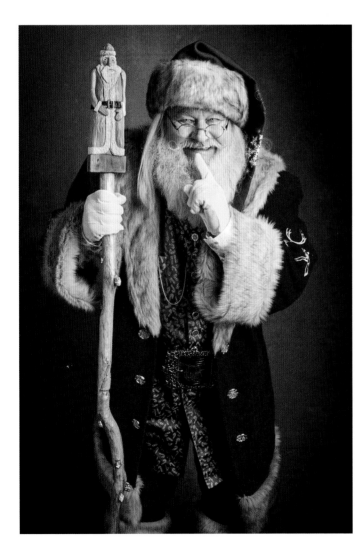

Thanks & Acknowledgments

———

Many people contributed to the success of this project. First and foremost, I thank each and every one of the one hundred-plus Santas who participated. They are all professionals dedicated to keeping the tradition and character of Santa Claus alive and well. They fulfill their duties tirelessly, with good cheer and an enduring commitment to the spirit of the season. It was an honor and a pleasure to meet and photograph them.

All of our studio sessions benefited enormously from the expertise, creativity, and support of Jonny Edward. He is a superb fashion photographer and lighting expert. Jonny's guidance, assistance, energy, and keen eye contributed much to the success of this project.

My friend, colleague, and photography mentor Nat Coalson played an essential role in helping edit, refine, and process hundreds of these images. His expertise is unparalleled, as is his eye for detail, nuance, composition, and color. We've worked together for over a decade and I continue to learn from him every day.

Rick Rosenthal is the dean of Northern Lights Santa Academy (Atlanta, Georgia) and is an agent for hundreds of professional holiday performers. He is a tireless promoter of professionalism in the Santa industry, and has been a Santa himself for fifty years. Rick and his wife, Tracy, were instrumental in introducing us to many of the Santas profiled in this book. Their assistance on scheduling and logistics made our photo shoots productive and efficient.

Susen Mesco is the founder of the Professional
Santa Claus School (Denver, Colorado) and one of the
top agents for Santas worldwide. She's been a major player
in the industry for more than thirty-five years and each
year places hundreds of Santas with shopping malls,
corporations, private event planners, and public organiza-
tions. She was generous with her time and support for this
project, and introduced us to some of her top Santas. Susen
was inducted into the Santa Claus Hall of Fame in 2019,
one of only a handful of women to receive this honor.

Thanks to Lauren Sharp and Maggie Cooper of
Aevitas Creative Management. Their belief in this project
and their efforts to find a suitable home for it led us to
Princeton Architectural Press and the book you see today.

Lynn Grady, Paul Wagner, Lia Hunt, Jessica Tackett,
and Wes Seeley, and the entire team at Princeton
Architectural Press have been a pleasure to work with.
Their enthusiasm for this project, and their creativity
and support, have made my job easy.

Our studio sessions were run with efficiency and
good cheer due to the assistance and support of Alice Park
and Leneille Moon (Atlanta, Georgia), Santa Larry Shaw
and Matt Corsaro (Carmel, Indiana), Bill Morton and Rina
Bale (Dallas, Texas), Pam Ashley (Houston, Texas), and
Andrew Schneps (Norfolk, Virginia).

Last but certainly not least, thanks to my wife, Beth,
a huge Santa fan, whose patience I'm sure I tested with
endless talk of this project.

THOMAS TOTH

RON COOPER is a travel, documentary,
and portrait photographer based in Denver, Colorado.
His work celebrates humankind, including people
who adopt personas outside of their daily lives—clowns,
drag queens, Civil War reenactors, and professional
Santas. *We Are Santa* is his first book.

—

The author will contribute all proceeds from
We Are Santa to **Children's Hospital of Colorado**,
an extraordinary place with dedicated doctors,
nurses, technicians, administrators, and staff who
work magic every day in caring for sick kids
and in doing pioneering research to eradicate
childhood disease.